REALMS OF
TOLKIEN

TOLKIEN

REALMS OF TOLKIEN

Images of Middle-earth

HarperPrism
An Imprint of HarperPaperbacks

 HarperPaperbacks

A Division of HarperCollins*Publishers*
10 East 53rd Street, New York, N.Y. 10022-5299

Contents

Biography of JRR Tolkien

John Ronald Reuel Tolkien was born on 3 January 1892 at Bloemfontein in the Orange Free State, but at the age of four he was taken by his mother, Mabel Suffield, together with his younger brother, Hilary, back to England for 'home leave'. After his father's death from rheumatic fever, the family made their home at Sarehole, on the south-eastern edge of Birmingham. Ronald spent a happy childhood in the Sarehole countryside, and his sensibility to the rural landscape can clearly be seen both in his writing and in his pictures.

After his mother's death, when Ronald was twelve, he and Hilary became wards of a kindly priest at the Birmingham Oratory. They both attended King Edward's School, Birmingham, where Ronald achieved distinction in Classics, and also encountered Anglo-Saxon and Middle English. At this time he began to develop his linguistic abilities by inventing languages which he related to 'fairy' or 'elvish' people.

After taking a First in English Language and Literature at Exeter College, Oxford, Tolkien married Edith Bratt, with whom he had formed an attachment when they both lived in the same lodging-house in Birmingham. He was also commissioned in the Lancashire Fusiliers and served in the Battle of the Somme, where two of his three closest friends were killed.

After the war, he obtained a post on the New English Dictionary, and began to write the mythological and legendary cycle which he originally called 'The Book of Lost Tales' but which eventually became known as *The Silmarillion*.

In 1920 Tolkien, now with two children, was appointed as Reader in the English Language at the University of Leeds, a post that was converted to a Professorship four years later. He distinguished himself by his lively and imaginative teaching, and in 1925 was elected Rawlinson and Bosworth Professor of Anglo-Saxon at Oxford, where he worked with great skill and enthusiasm for many years. Indeed he was one of the most accomplished philologists that has ever been known. Meanwhile, his family, now numbering four children, encouraged Tolkien to use his mythological imagination to deal with more homely topics. For them he wrote and illustrated *The Father Christmas Letters*, and to them he told the story of *The Hobbit*, published some years later in 1937 by Stanley Unwin, who then asked for a 'sequel'. At first, Tolkien applied himself only unwillingly to this task, but soon he was inspired, and what he had meant to be another book for children grew into *The Lord of the Rings*, truly a sequel to *The Silmarillion* rather than to *The Hobbit*. This huge story took twelve years to complete, and it was not published until Tolkien was approaching retirement. When it did reach print, its extraordinary popularity took him by surprise.

After retirement, Tolkien and his wife lived first in the Headington area of Oxford, then moved to Bournemouth, but after his wife's death in 1971 Tolkien returned to Oxford and died after a very brief illness on 2 September 1973, leaving his great mythological and legendary cycle *The Silmarillion* to be edited for publication by his son, Christopher.

TREEBEARD

Inger Edelfeldt

As for Treebeard, he first laved his feet in the basin beyond the arch, and then he drained his bowl at one draught, one long, slow draught. The hobbits thought he would never stop.

At last he set the bowl down again. 'Ah‑ah,' he sighed. 'Hm, hoom, now we can talk easier. You can sit on the floor, and I will lie down; that will prevent this drink from rising to my head and sending me to sleep.'

THE TWO TOWERS

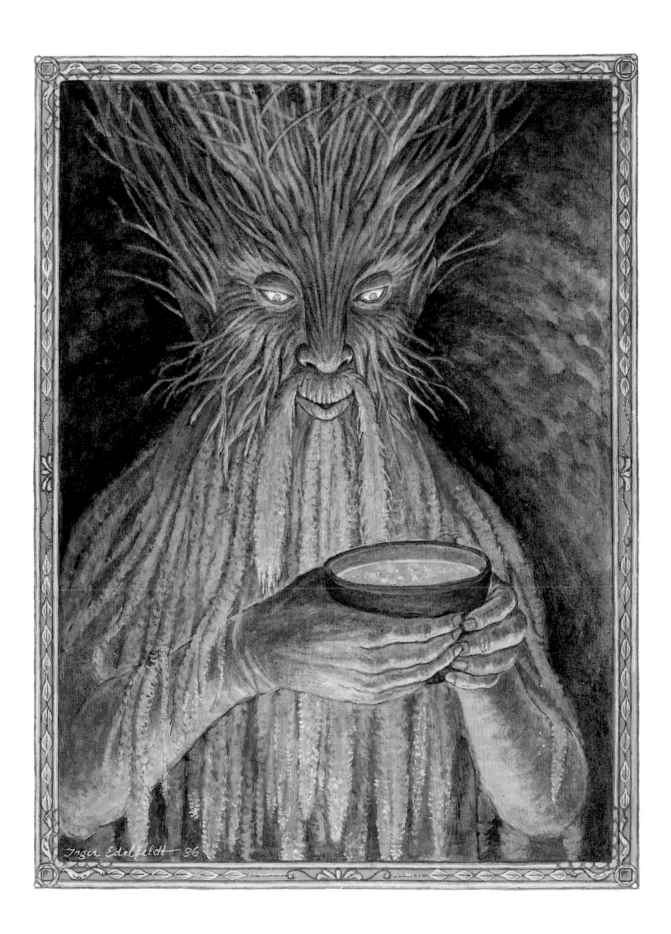

Inger Edelfeldt – 96

GANDALF'S ESCAPE FROM ORTHANC

Fletcher

'So it was that when summer waned, there came a night of moon, and Gwaihir the Windlord, swiftest of the Great Eagles, came unlooked-for to Orthanc; and he found me standing on the pinnacle. Then I spoke to him and he bore me away, before Saruman was aware. I was far from Isengard, ere the wolves and orcs issued from the gate to pursue me.

'"How far can you bear me?" I said to Gwaihir.

'"Many leagues," said he, "but not to the ends of the earth. I was sent to bear tidings not burdens."

THE FELLOWSHIP OF THE RING

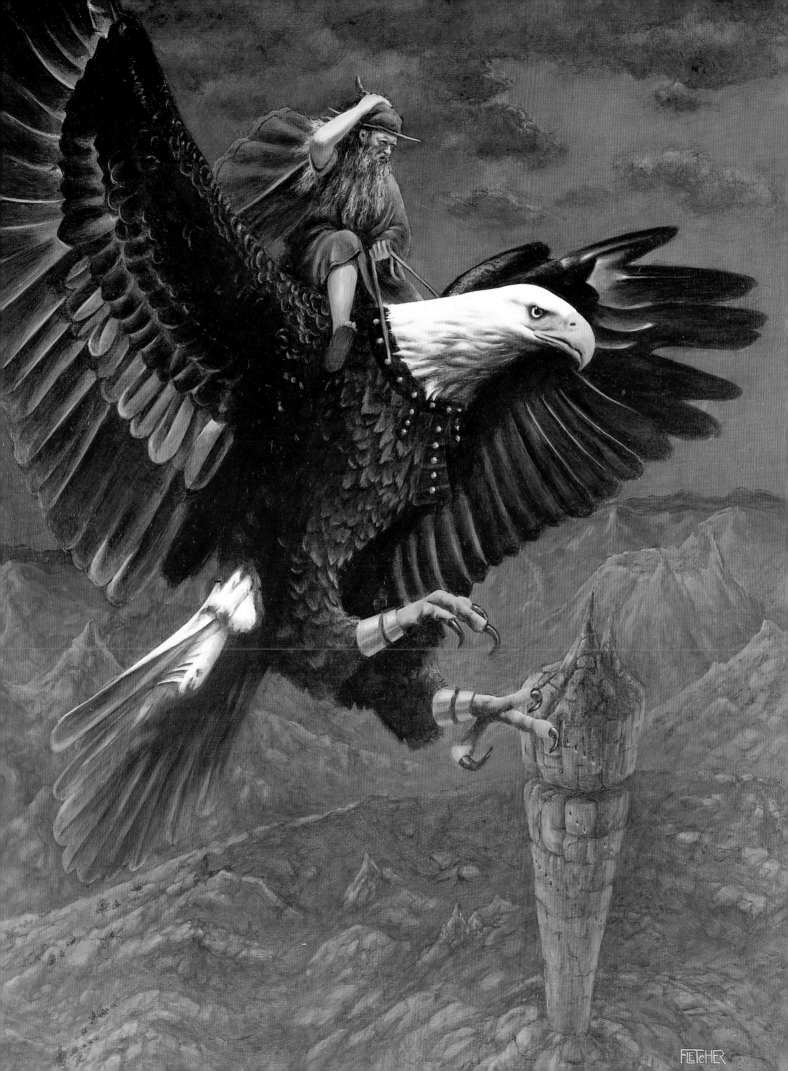

GOLLUM

Nicholas Bayrachny

Deep down here by the dark water lived old Gollum, a small slimy creature. I don't know where he came from, nor who or what he was. He was Gollum – as dark as darkness, except for two big round pale eyes in his thin face. He had a little boat, and he rowed about quite quietly on the lake; for lake it was, wide and deep and deadly cold. He paddled it with large feet dangling over the side, but never a ripple did he make. Not he. He was looking out of his pale lamp-like eyes for blind fish, which he grabbed with his long fingers as quick as thinking.

THE HOBBIT

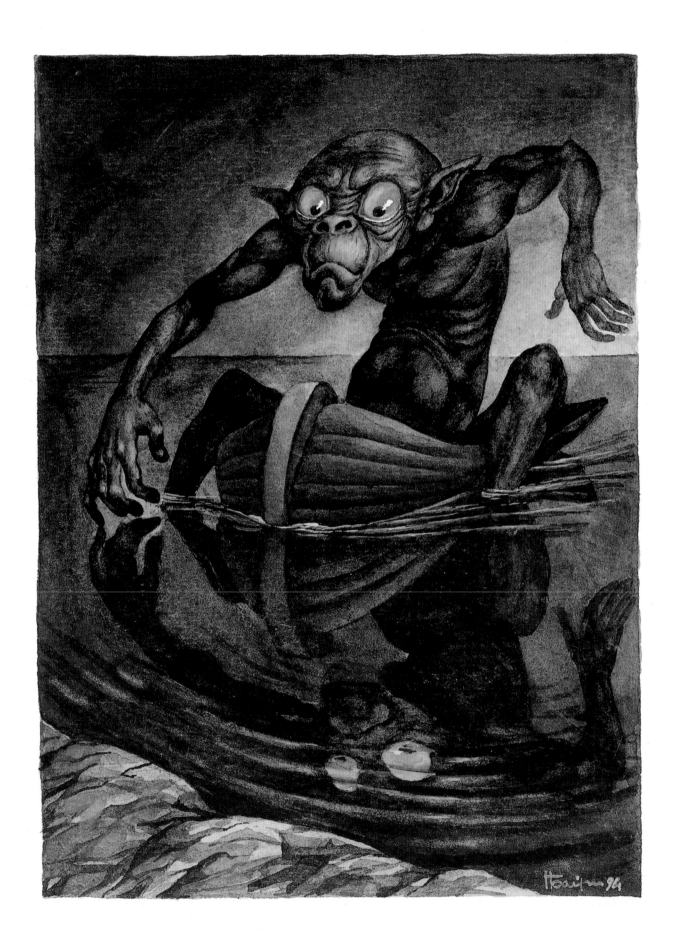

GANDALF AND THE BALROG

John Howe

There was a ringing clash and a stab of white fire. The Balrog fell back and its sword flew up in molten fragments. The wizard swayed on the bridge, stepped back a pace, and then again stood still.

'You cannot pass!' he said.

With a bound the Balrog leaped full upon the bridge. Its whip whirled and hissed.

'He cannot stand alone!' cried Aragorn suddenly and ran back along the bridge. 'Elendil!' he shouted. 'I am with you, Gandalf!'

'Gondor!' cried Boromir and leaped after him.

At that moment Gandalf lifted his staff, and crying aloud he smote the bridge before him. The staff broke asunder and fell from his hand. A blinding sheet of white flame sprang up. The bridge cracked. Right at the Balrog's feet it broke, and the stone upon which it stood crashed into the gulf, while the rest remained, poised, quivering like a tongue of rock thrust out into emptiness.

THE FELLOWSHIP OF THE RING

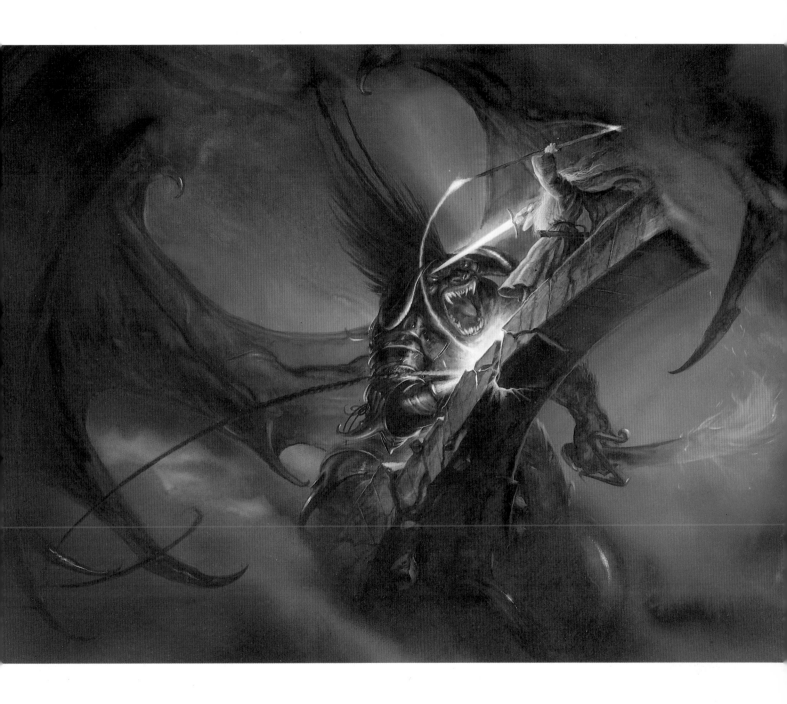

THE NAZGÛL

Lode Claes

Pippin did not answer ... he thought of the long fingers of that Shadow: of the orcs in the woods and the mountains, the treason of Isengard, the birds of evil eye, and the Black Riders even in the lanes of the Shire – and of the winged terror, the Nazgûl. He shuddered, and hope seemed to wither. And even at that moment the sun for a second faltered and was obscured, as though a dark wing had passed across it. Almost beyond hearing he thought he caught, high and far up in the heavens, a cry: faint, but heart-quelling, cruel and cold. He blanched and cowered against the wall.

THE RETURN OF THE KING

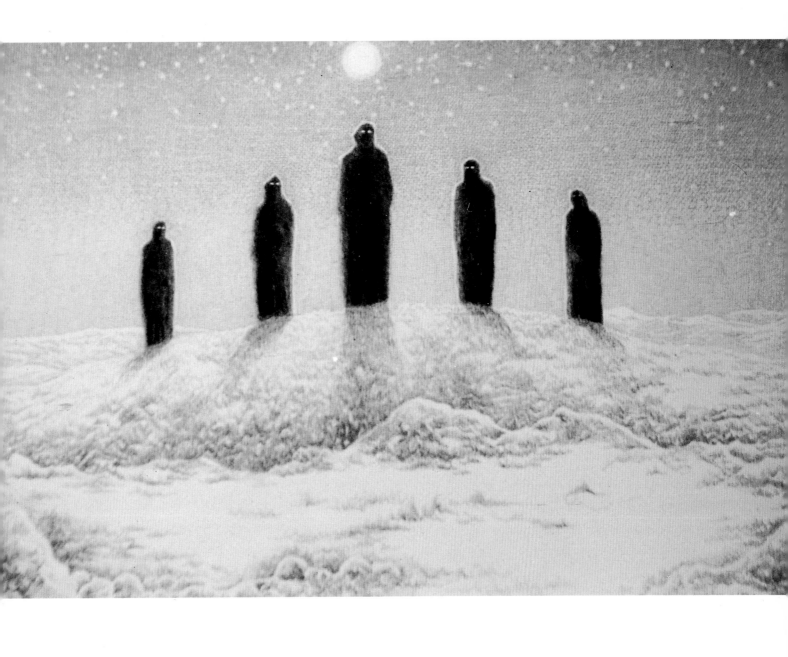

A PLEASANT AWAKENING

Carol Emery Phenix

Frodo woke and found himself lying in bed. At first he thought that he had slept late, after a long unpleasant dream that still hovered on the edge of memory. Or perhaps he had been ill? But the ceiling looked strange; it was flat, and it had dark beams richly carved. He lay a little while longer looking at patches of sunlight on the wall, and listening to the sound of a waterfall.

'Where am I, and what is the time?' he said aloud to the ceiling.

'In the House of Elrond, and it is ten o'clock in the morning,' said a voice …

'Gandalf!' cried Frodo, sitting up. There was the old wizard, sitting in a chair by the open window.

'Yes,' he said, 'I am here. And you are lucky to be here too, after all the absurd things you have done since you left home.'

THE FELLOWSHIP OF THE RING

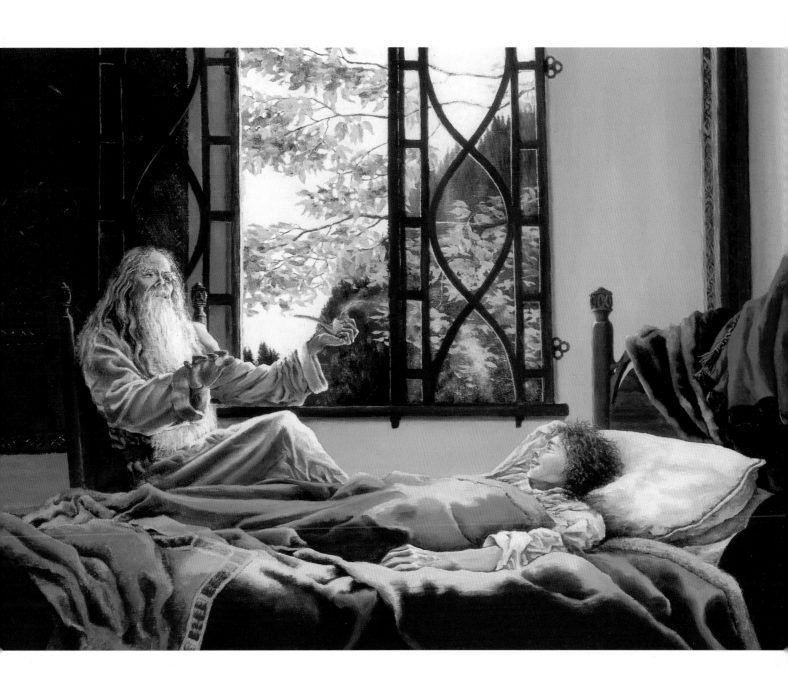

THROUGH THE MARSHES

Ted Nasmith

As the day wore on the light increased a little, and the mists lifted, growing thinner and more transparent. Far above the rot and vapours of the world the Sun was riding high and golden now in a serene country with floors of dazzling foam, but only a passing ghost of her could they see below, bleared, pale, giving no colour and no warmth. But even at this faint reminder of her presence Gollum scowled and flinched.

THE TWO TOWERS

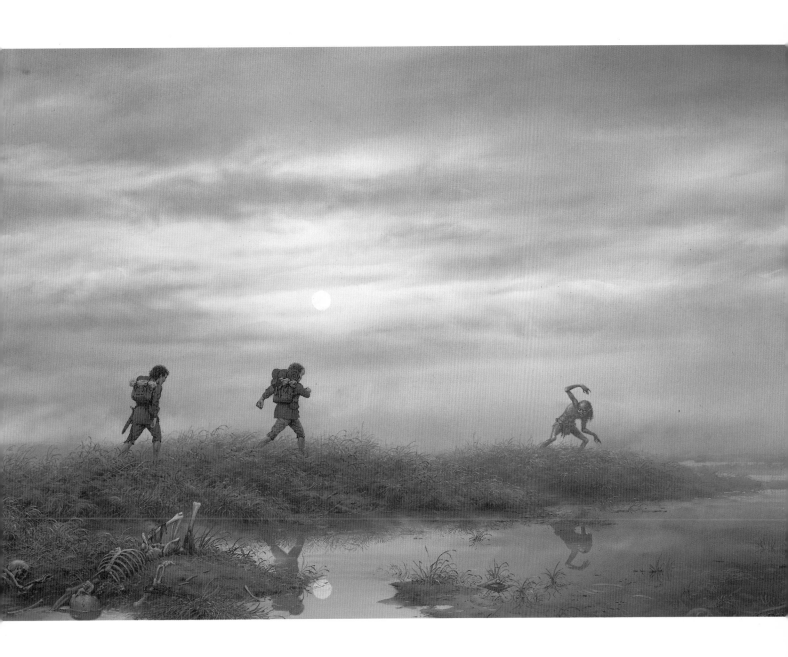

THE BLACK RIDERS

Alan Lee

The house at Crickhollow stood silent. Fatty Bolger opened the door cautiously and peered out. A feeling of fear had been growing on him all day, and he was unable to rest or go to bed: there was a brooding threat in the breathless night-air. As he stared out into the gloom, a black shadow moved under the trees; the gate seemed to open of its own accord and close again without a sound. Terror seized him ...

The night deepened. There came the soft sound of horses led with stealth along the lane. Outside the gate they stopped, and three black figures entered, like shades of night creeping across the ground. One went to the door, one to the corner of the house on either side; and there they stood, as still as the shadows of stones, while night went slowly on. The house and the quiet trees seemed to be waiting breathlessly.

THE FELLOWSHIP OF THE RING

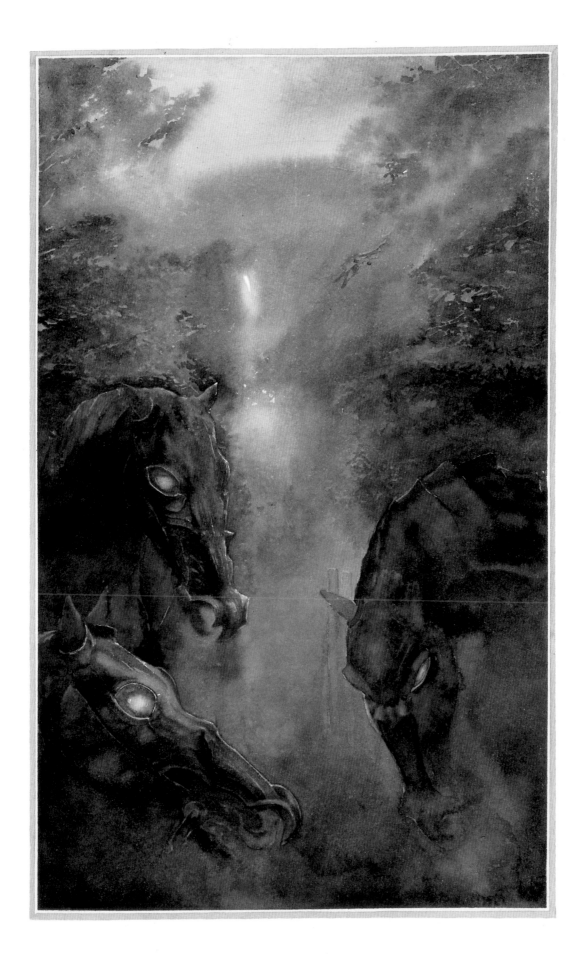

LEGOLAS DRAWS THE BOW
OF GALADRIEL

Michael Kaluta

Legolas laid down his paddle and took up the bow that he had brought from Lórien. Then he sprang ashore and climbed a few paces up the bank. Stringing the bow and fitting an arrow he turned, peering back over the River into the darkness. Across the water there were shrill cries, but nothing could be seen.

Frodo looked up at the Elf standing tall above him, as he gazed into the night, seeking a mark to shoot at. His head was dark, crowned with sharp white stars that glittered in the black pools of the sky behind.

THE FELLOWSHIP OF THE RING

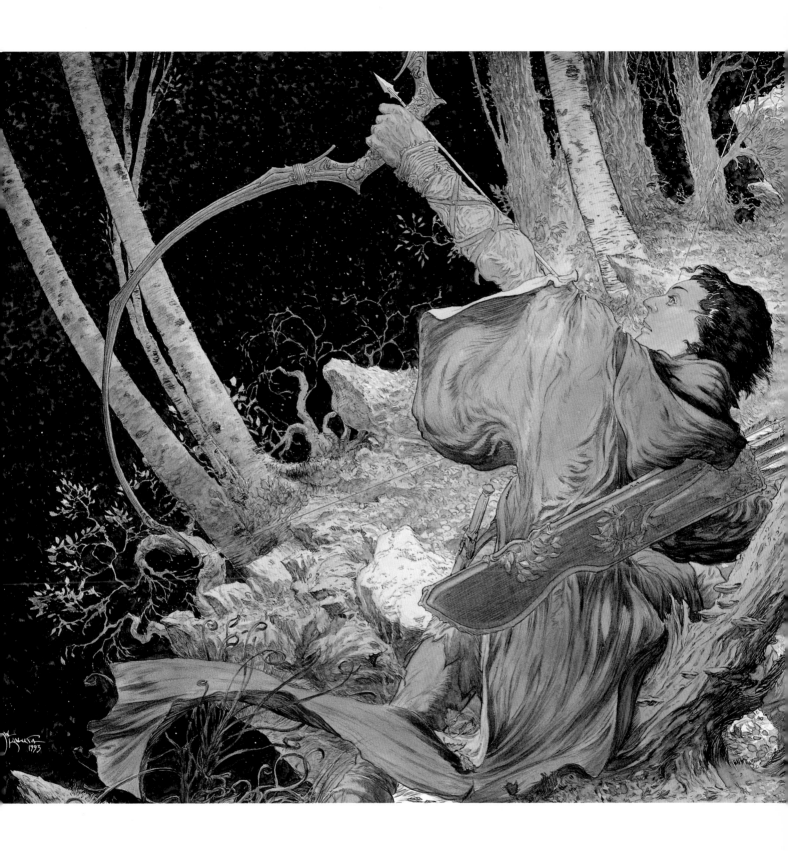

PURSUIT IN ROHAN

Ted Nasmith

The trail led them north along the top of the escarpment, and at length they came to a deep cleft carved in the rock by a stream that splashed noisily down. In the narrow ravine a rough path descended like a steep stair into the plain.

At the bottom they came with a strange suddenness on the grass of Rohan. It swelled like a green sea up to the very foot of the Emyn Muil ... They seemd to have left winter clinging to the hills behind. Here the air was softer and warmer, and faintly scented, as if Spring was already stirring and the sap was flowing again in herb and leaf.

THE TWO TOWERS

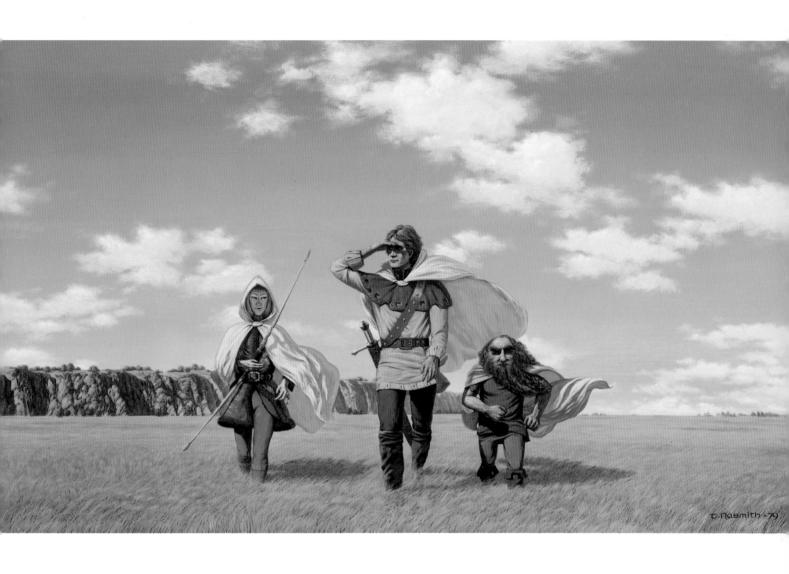

RIVENDELL

Alan Lee

'Who made the flood?' asked Frodo.
'Elrond commanded it,' answered Gandalf. 'The river of this valley is under his power, and it will rise in anger when he has great need to bar the Ford. As soon as the captain of the Ringwraiths rode into the water the flood was released. If I may say so, I added a few touches of my own: you may not have noticed, but some of the waves took the form of great white horses with shining white riders; and there were many rolling and grinding boulders. For a moment I was afraid that we had let loose too fierce a wrath, and the flood would get out of hand and wash you all away. There is great vigour in the waters that come down from the snows of the Misty Mountains.'

THE FELLOWSHIP OF THE RING

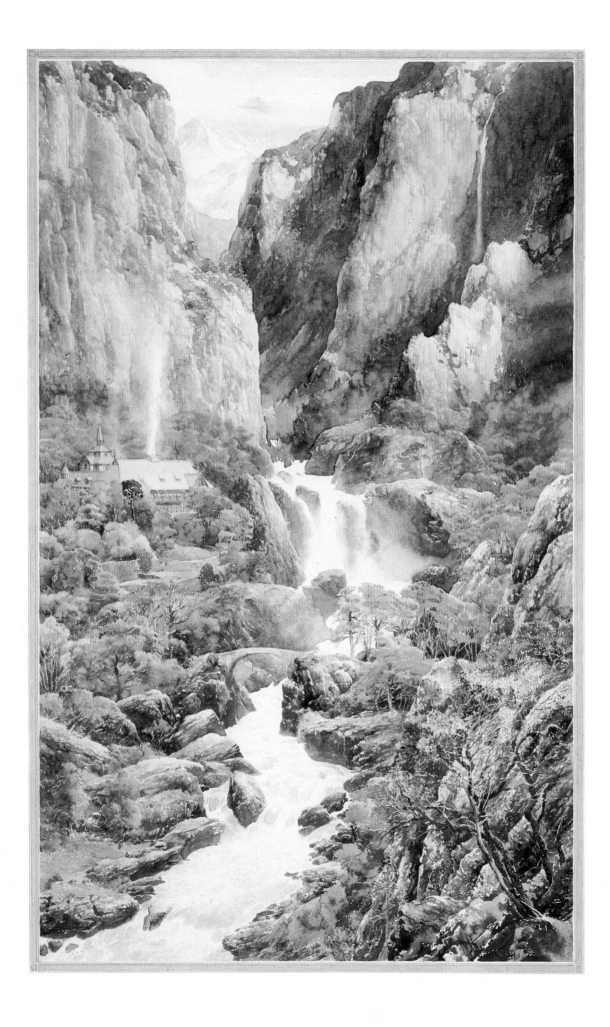

RIDDLES IN THE DARK

Capucine Mazille

'What's he got in his handses?' said Gollum, looking at the sword, which he did not quite like.

'A sword, a blade which came out of Gondolin!'

'Sssss' said Gollum, and became quite polite. 'Praps we sits here and chats with it a bitsy, my preciousss. It likes riddles, praps it does, does it?'...

'Very well,' said Bilbo ... 'You ask first,'

So Gollum hissed:

> *What has roots as nobody sees,*
> *Is taller than trees,*
> *Up, up it goes,*
> *And yet never grows?*

'Easy!' said Bilbo. 'Mountain, I suppose.'

THE HOBBIT

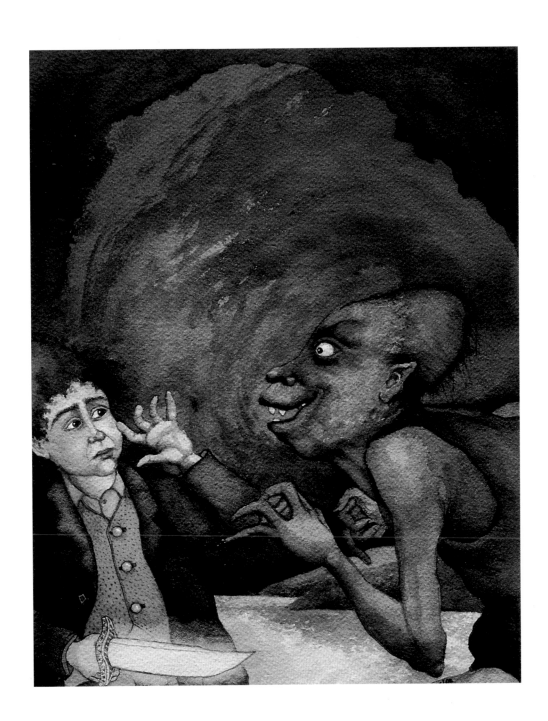

ULMO, THE LORD OF THE WATERS

John Howe

Then Tuor bowed in reverence, for it seemed to him that he beheld a mighty king. A tall crown he wore like silver, from which his long hair fell down as foam glimmering in the dusk; and as he cast back the grey mantle that hung about him like a mist, behold! he was clad in a gleaming coat, close-fitted as the mail of a mighty fish, and in a kirtle of deep green that flashed and flickered with sea-fire as he strode slowly towards the land … He set no foot upon the shore, but standing knee-deep in the shadowy sea he spoke to Tuor, and then for the light of his eyes and for the sound of his deep voice that came as it seemed from the foundations of the world, fear fell upon Tuor and he cast himself down upon the sand.

UNFINISHED TALES

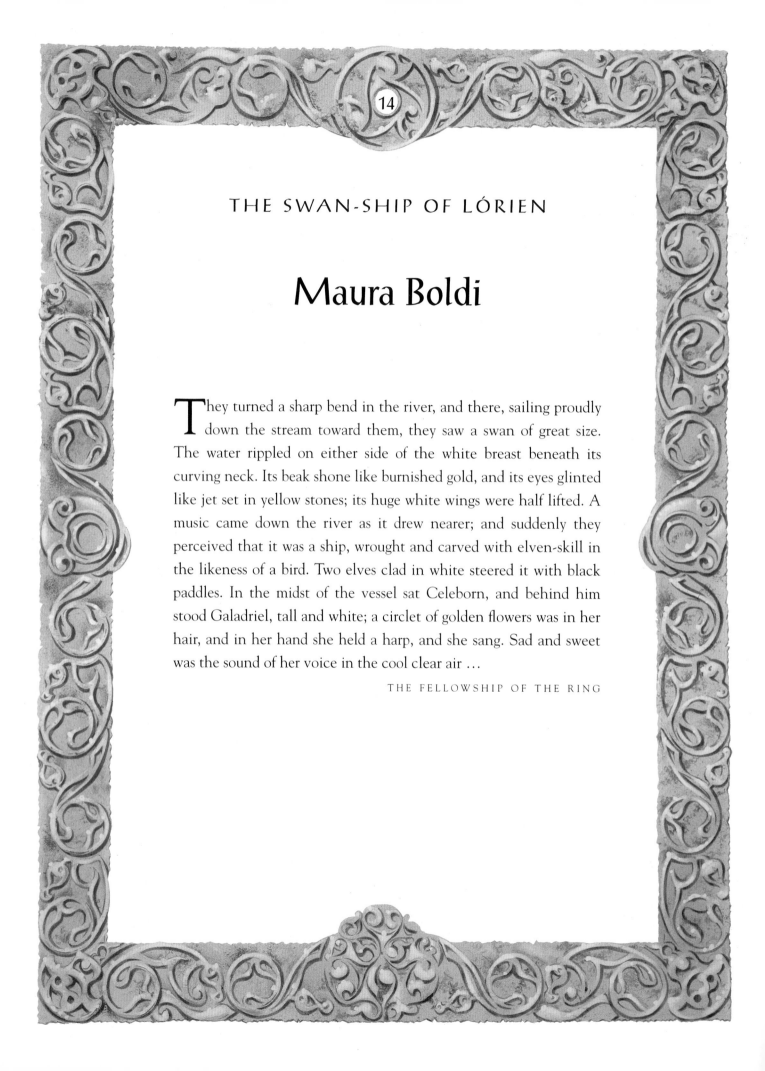

THE SWAN-SHIP OF LÓRIEN

Maura Boldi

They turned a sharp bend in the river, and there, sailing proudly down the stream toward them, they saw a swan of great size. The water rippled on either side of the white breast beneath its curving neck. Its beak shone like burnished gold, and its eyes glinted like jet set in yellow stones; its huge white wings were half lifted. A music came down the river as it drew nearer; and suddenly they perceived that it was a ship, wrought and carved with elven-skill in the likeness of a bird. Two elves clad in white steered it with black paddles. In the midst of the vessel sat Celeborn, and behind him stood Galadriel, tall and white; a circlet of golden flowers was in her hair, and in her hand she held a harp, and she sang. Sad and sweet was the sound of her voice in the cool clear air …

THE FELLOWSHIP OF THE RING

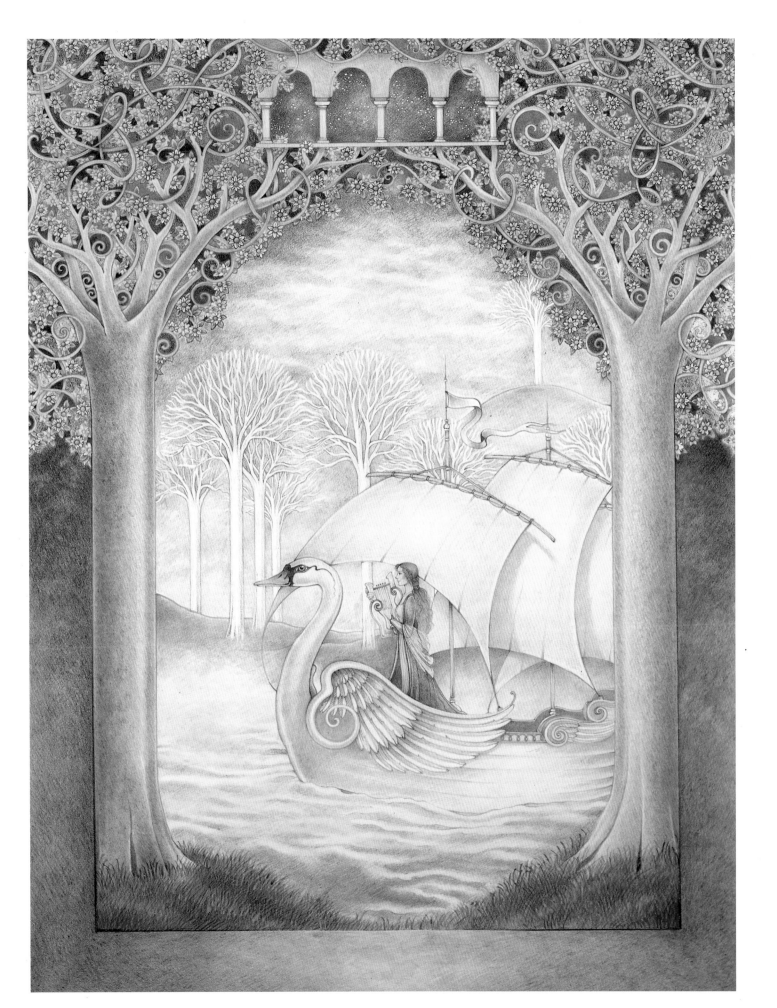

FRODO'S VISION

Cor Blok

I n the dead night, Frodo lay in a dream without light. Then he saw the young moon rising; under its thin light there loomed before him a black wall of rock, pierced by a dark arch like a great gate. It seemed to Frodo that he was lifted up, and passing over he saw that the rock-wall was a circle of hills, and that within it was a plain, and in the midst of the plain stood a pinnacle of stone, like a vast tower but not made by hands. On its top stood the figure of a man. The moon as it rose seemed to hang for a moment above his head and glistened in his white hair as the wind stirred it. Up from the dark plain below came the crying of fell voices, and the howling of many wolves. Suddenly a shadow, like the shape of great wings, passed across the moon … 'Black Riders!' thought Frodo as he wakened, with the sound of hoofs still echoing in his mind.

THE FELLOWSHIP OF THE RING

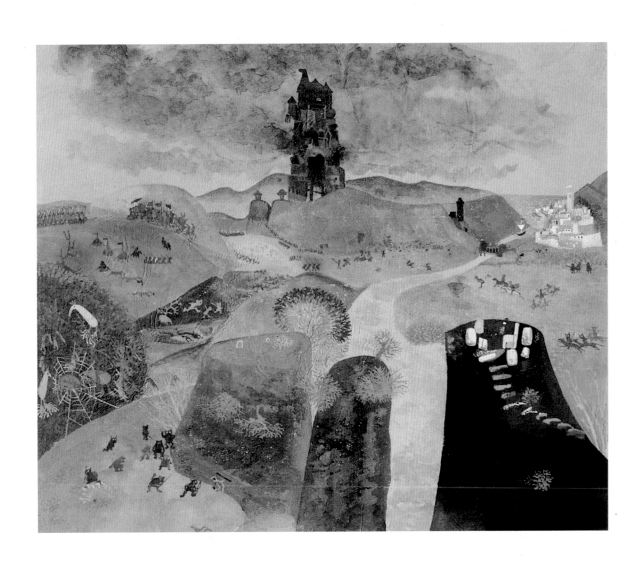

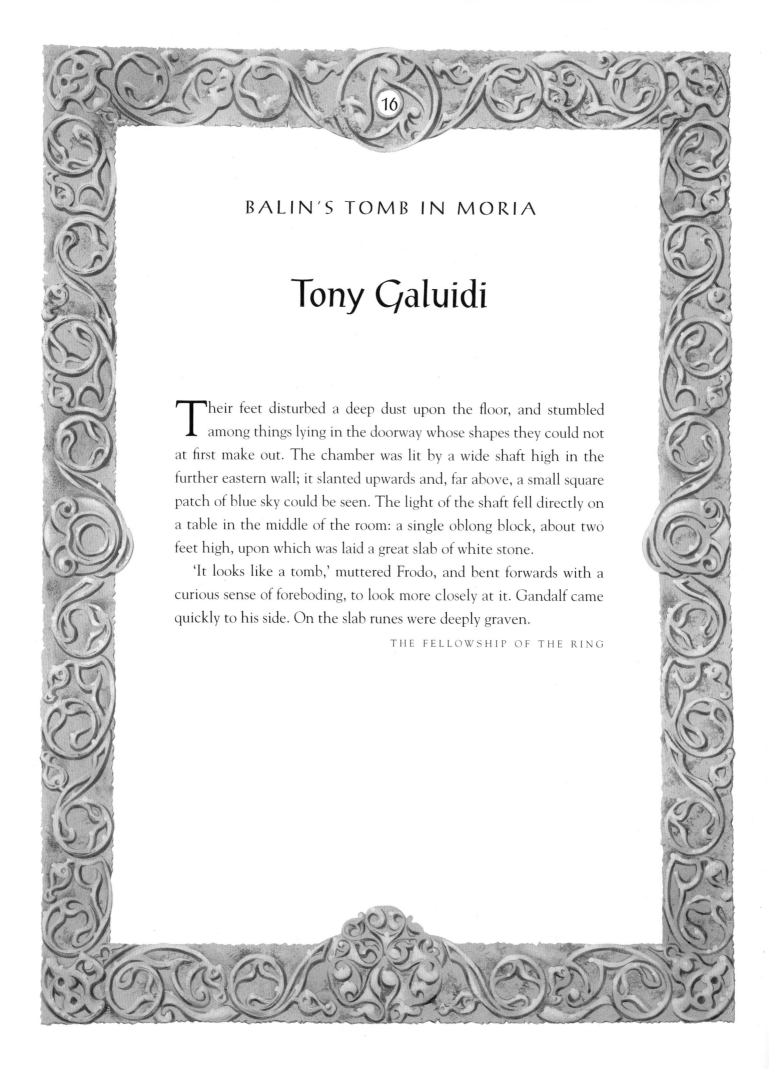

BALIN'S TOMB IN MORIA

Tony Galuidi

Their feet disturbed a deep dust upon the floor, and stumbled among things lying in the doorway whose shapes they could not at first make out. The chamber was lit by a wide shaft high in the further eastern wall; it slanted upwards and, far above, a small square patch of blue sky could be seen. The light of the shaft fell directly on a table in the middle of the room: a single oblong block, about two feet high, upon which was laid a great slab of white stone.

'It looks like a tomb,' muttered Frodo, and bent forwards with a curious sense of foreboding, to look more closely at it. Gandalf came quickly to his side. On the slab runes were deeply graven.

THE FELLOWSHIP OF THE RING

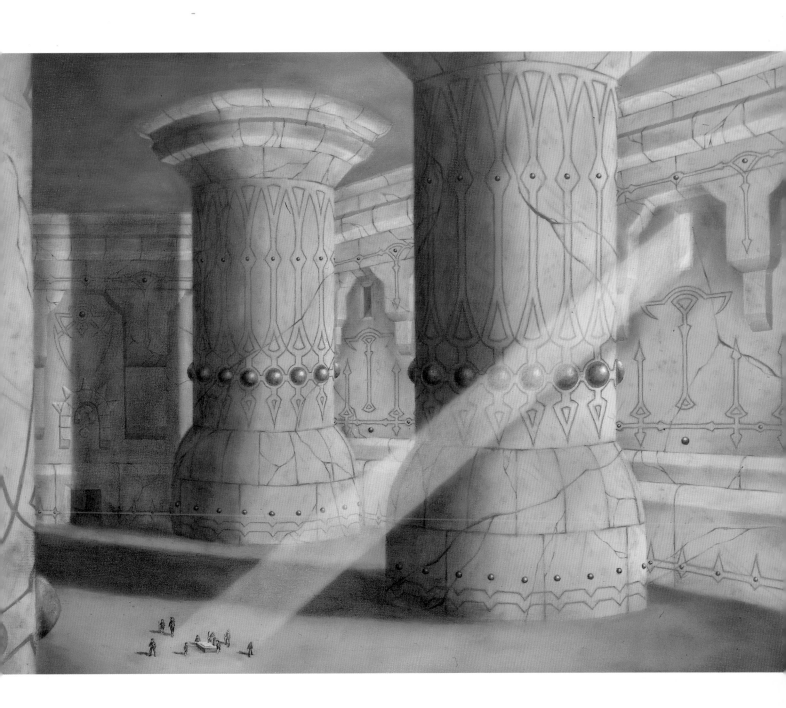

GANDALF AND PIPPIN

Luca Michelucci

Pippin was recovering. He was warm, but the wind in his face was keen and refreshing. He was with Gandalf. The horror of the stone and of the hideous shadow over the moon was fading, things left behind in the mists of the mountains or in a passing dream. He drew a deep breath.

'I did not know you rode bare-back, Gandalf,' he said. 'You haven't a saddle or a bridle!'

'I do not ride elf-fashion, except on Shadowfax,' said Gandalf. 'But Shadowfax will have no harness. You do not ride Shadowfax: he is willing to carry you – or not. If he is willing, that is enough. It is then his business to see that you remain on his back, unless you jump off into the air.'

THE TWO TOWERS

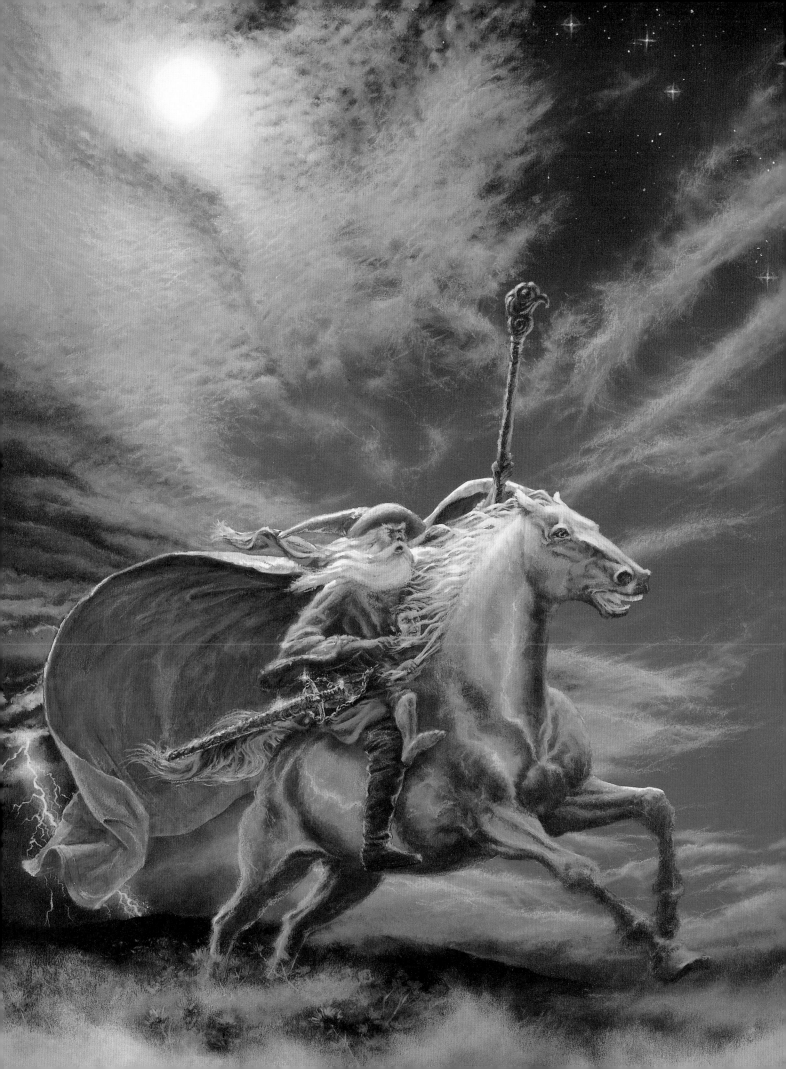

ACROSS GORGOROTH

Ted Nasmith

The last stage of their journey to Orodruin came, and it was a torment greater than Sam had ever thought that he could bear. He was in pain, and so parched that he could no longer swallow even a mouthful of food. It remained dark, not only because of the smokes of the Mountain: there seemed to be a storm coming up, and away to the south-east there was a shimmer of lightnings under the black skies. Worst of all, the air was full of fumes; breathing was painful and difficult, and a dizziness came on them, so that they staggered and often fell. And yet their wills did not yield, and they struggled on.

THE RETURN OF THE KING

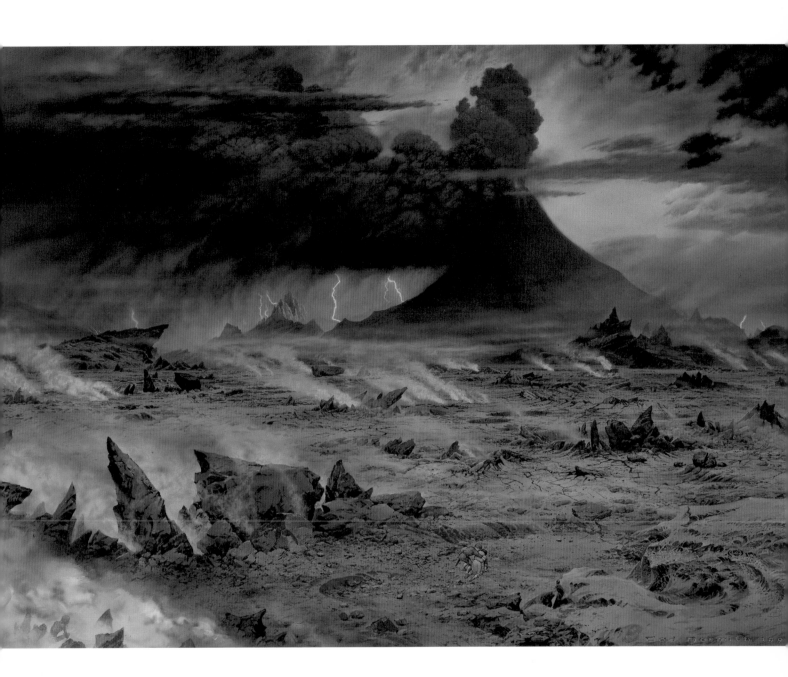

TREEBEARD, MERRY AND PIPPIN

Eta Muscad

Treebeard lifted two great vessels and stood them on the table. They seemed to be filled with water; but he held his hands over them, and immediately they began to glow, one with a golden and the other with a rich green light; and the blending of the two lights lit the bay, as if the sun of summer was shining through a roof of young leaves …

The drink was like water, indeed very like the taste of the draughts they had drunk from the Entwash near the borders of the forest, and yet there was some scent or savour in it which they could not describe: it was faint, but it reminded them of a distant wood borne from afar by a cool breeze at night. The effect of the draught began at the toes, and rose steadily through every limb, bringing refreshment and vigour as it coursed upwards, right to the tips of the hair. Indeed the hobbits felt that the hair on their heads was actually standing up, waving and curling and growing.

THE TWO TOWERS

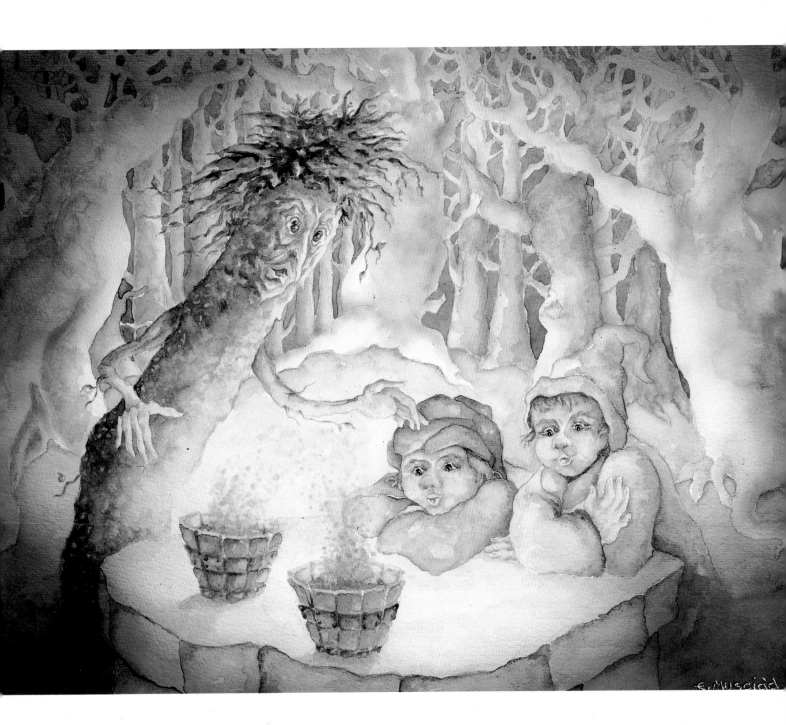

GANDALF COMES TO HOBBITON

John Howe

Gandalf had not been to Hobbiton for some time: since Bilbo disappeared his visits had become fewer and more secret. The people of Hobbiton had not in fact seen or at any rate noticed him for many years: he used to come quietly up to the door of Bag-end in the twilight and step in without knocking …

<div align="right">THE RETURN OF THE SHADOW</div>

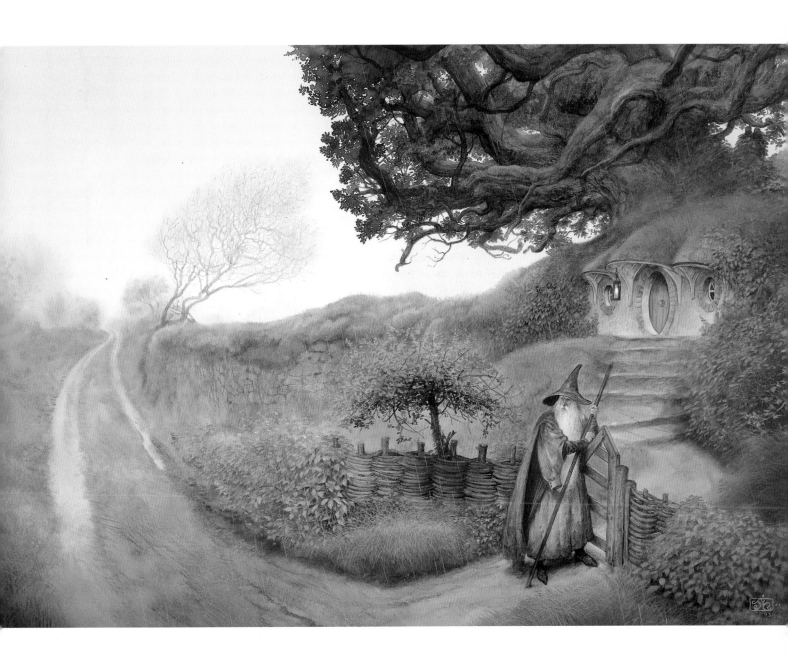

THE TAMING OF SMÉAGOL

Alan Lee

Things would have gone ill with Sam, if he had been alone. But Frodo sprang up, and drew Sting from its sheath. With his left hand he drew back Gollum's head by his thin lank hair, stretching his long neck, and forcing his pale venomous eyes to stare up at the sky.

'Let go! Gollum,' he said. 'This is Sting. You have seen it before once upon a time. Let go, or you'll feel it this time! I'll cut your throat.'

Gollum collapsed and went as loose as wet string. Sam got up, fingering his shoulder. His eyes smouldered with anger, but he could not avenge himself: his miserable enemy lay grovelling on the stones whimpering.

THE TWO TOWERS

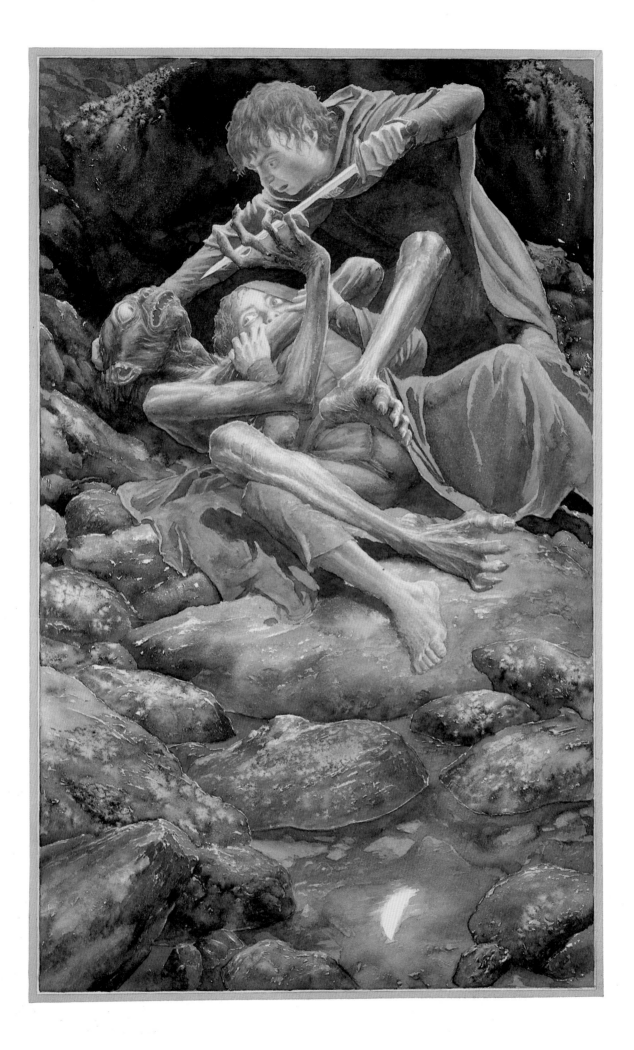

THÉODEN'S CHARGE AT HELM'S DEEP

Timothy Ide

'Helm! Helm!' the Riders shouted. 'Helm is arisen and comes back to war. Helm for Théoden King!'

And with that shout the king came. His horse was white as snow, golden was his shield, and his spear was long. At his right hand was Aragorn, Elendil's heir, behind him rode the lords of the House of Eorl the Young. Light sprang in the sky. Night departed.

'Forth Eorlingas!' With a cry and a great noise they charged. Down from the gates they roared, over the causeway they swept, and they drove through the hosts of Isengard as a wind among grass. Behind them from the Deep came the stern cries of men issuing from the caves, driving forth the enemy. Out poured all the men that were left upon the Rock. And ever the sound of blowing horns echoed in the hills.

On they rode, the king and his companions. Captains and champions fell or fled before them. Neither orc nor man withstood them. Their backs were to the swords and spears of the Riders and their faces to the valley. They cried and wailed, for fear and great wonder had come upon them with the rising of the day.

THE TWO TOWERS

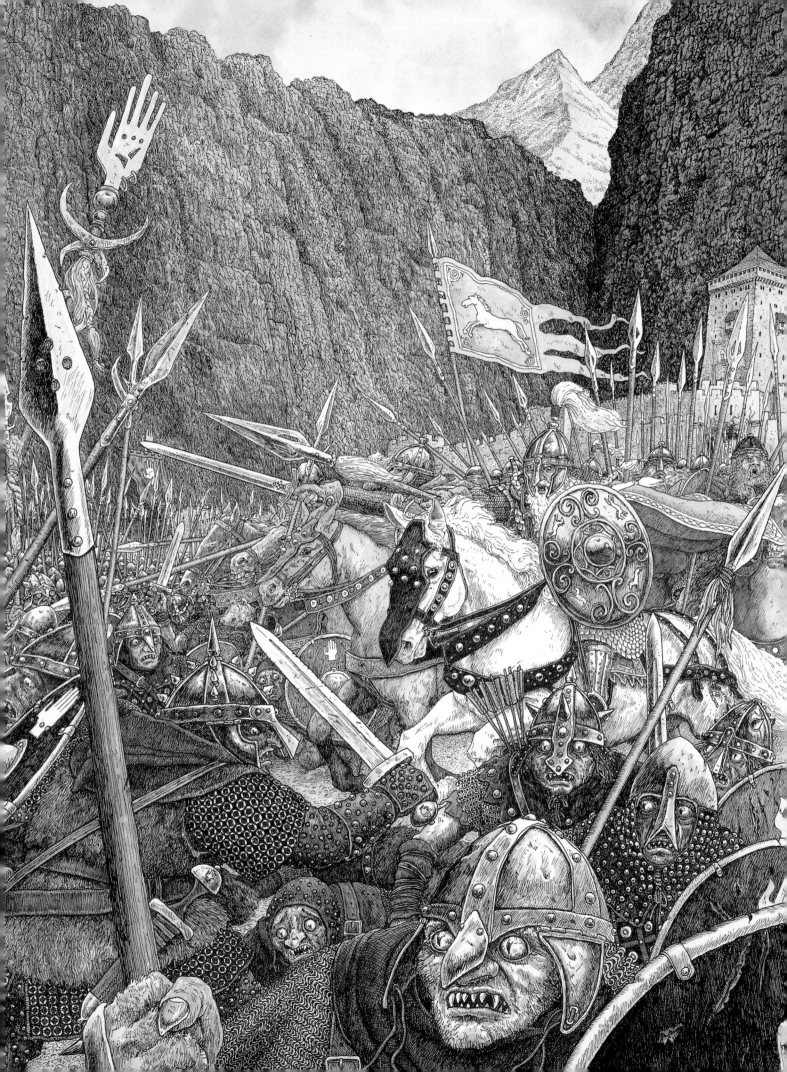

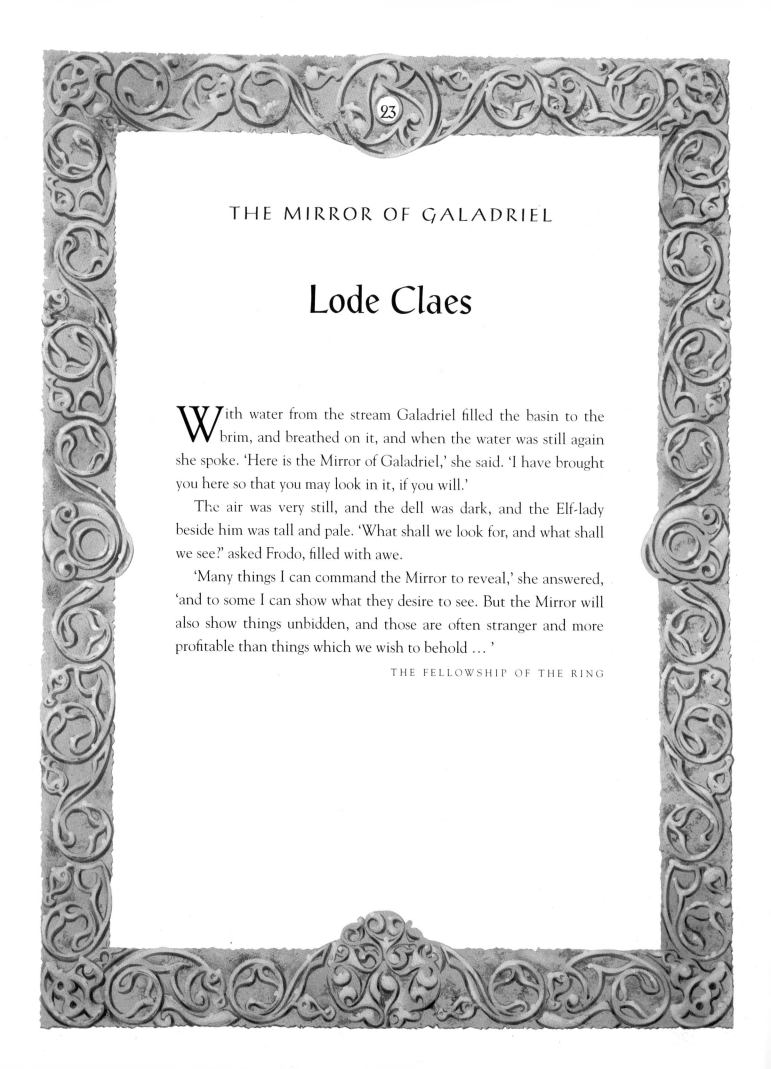

THE MIRROR OF GALADRIEL

Lode Claes

With water from the stream Galadriel filled the basin to the brim, and breathed on it, and when the water was still again she spoke. 'Here is the Mirror of Galadriel,' she said. 'I have brought you here so that you may look in it, if you will.'

The air was very still, and the dell was dark, and the Elf-lady beside him was tall and pale. 'What shall we look for, and what shall we see?' asked Frodo, filled with awe.

'Many things I can command the Mirror to reveal,' she answered, 'and to some I can show what they desire to see. But the Mirror will also show things unbidden, and those are often stranger and more profitable than things which we wish to behold ... '

THE FELLOWSHIP OF THE RING

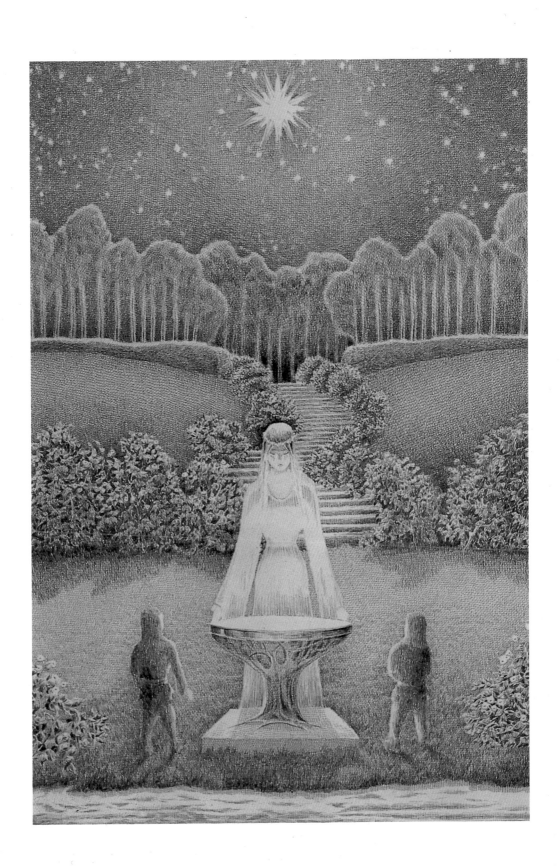

THÉODEN'S HALL

Alan Lee

A bitter chill came into the air. Slowly in the East the dark faded to a cold grey. Red shafts of light leapt above the black walls of the Emyn Muil far away upon their left. Dawn came clear and bright; a wind swept across their path, rushing through the bent grasses. Suddenly Shadowfax stood still and neighed. Gandalf pointed ahead.

'Look!' he cried, and they lifted their tired eyes. Before them stood the mountains of the South: white-tipped and streaked with black. The grass-lands rolled against the hills that clustered at their feet, and flowed up into many valleys still dim and dark, untouched by the light of dawn, winding their way into the heart of the great mountains. Immediately before the travellers the widest of these glens opened like a long gulf among the hills. Far inward they glimpsed a tumbled mountain-mass with one tall peak; at the mouth of the vale there stood like sentinel a lonely height. About its feet there flowed, as a thread of silver, the stream that issued from the dale; upon its brow they caught, still far away, a glint in the rising sun, a glimmer of gold.

THE TWO TOWERS

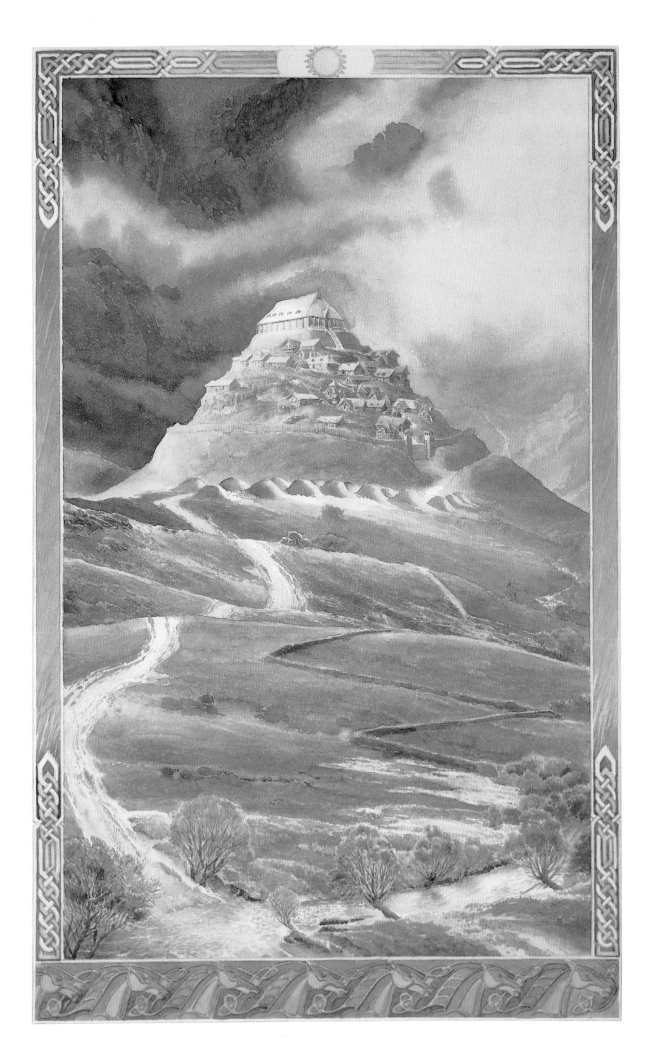

GANDALF APPROACHES THE GUARDED CITY

John Howe

Now after Gandalf had ridden for some time the light of day grew in the sky, and Pippin roused himself and looked up. To his left lay a sea of mist, rising to a bleak shadow in the East; but to his right great mountains reared their heads, ranging from the West to a steep and sudden end, as if in the making of the land the River had burst through a great barrier, carving out a mighty valley to be a land of battle and debate in times to come. And there where the White Mountains of Ered Nimrais came to their end he saw, as Gandalf had promised, the dark mass of Mount Mindolluin, the deep purple shadows of its high glens, and its tall face whitening in the rising day. And upon its out-thrust knee was the Guarded City, with its seven walls of stone …

THE RETURN OF THE KING

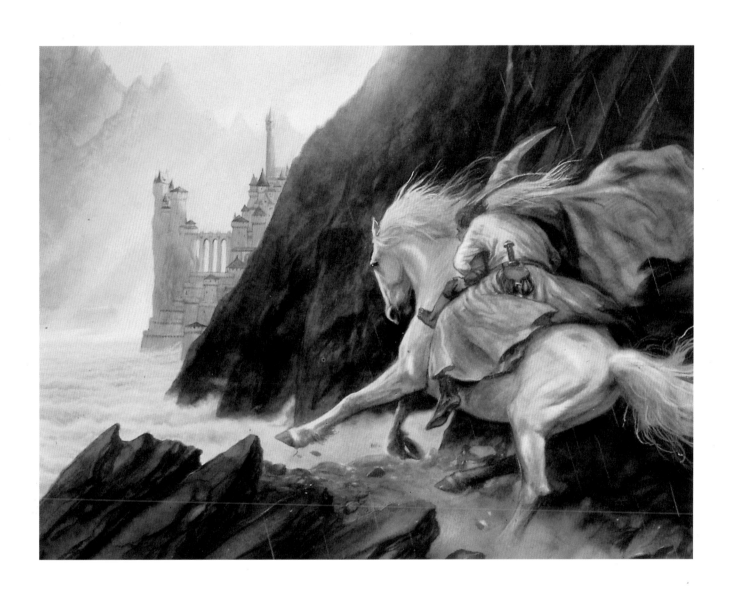

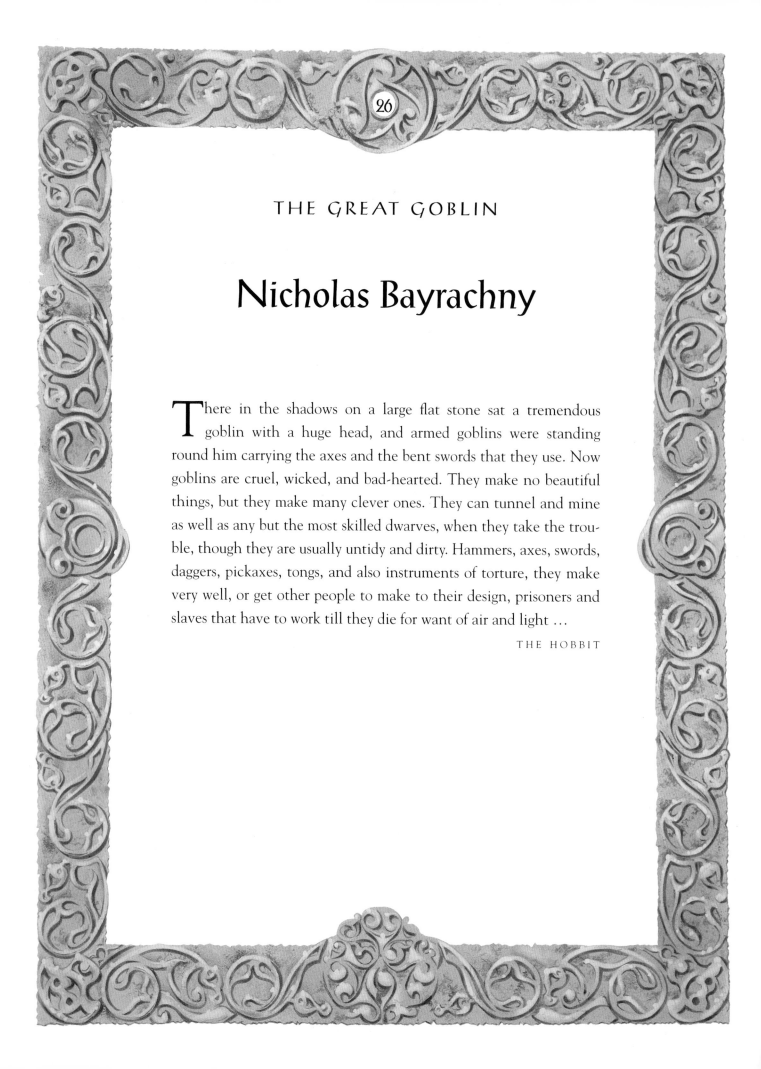

THE GREAT GOBLIN

Nicholas Bayrachny

There in the shadows on a large flat stone sat a tremendous goblin with a huge head, and armed goblins were standing round him carrying the axes and the bent swords that they use. Now goblins are cruel, wicked, and bad-hearted. They make no beautiful things, but they make many clever ones. They can tunnel and mine as well as any but the most skilled dwarves, when they take the trouble, though they are usually untidy and dirty. Hammers, axes, swords, daggers, pickaxes, tongs, and also instruments of torture, they make very well, or get other people to make to their design, prisoners and slaves that have to work till they die for want of air and light …

THE HOBBIT

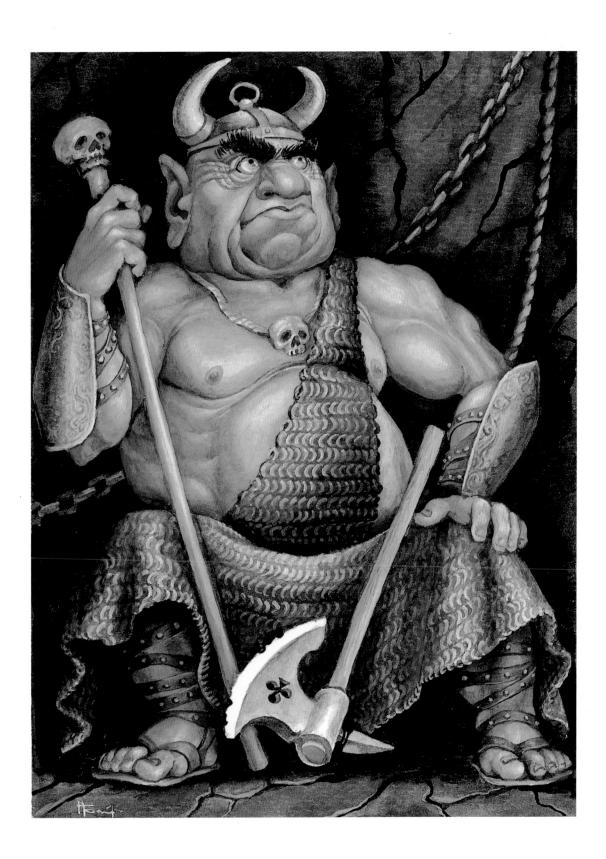

IN THE HOUSE OF BEORN

Capucine Mazille

Inside the hall it was now quite dark. Beorn clapped his hands, and in trotted four beautiful white ponies and several large long-bodied grey dogs. Beorn said something to them in a queer language like animal noises turned into talk …

Then baa – baa – baa! was heard, and in came some snow-white sheep led by a large coal-black ram. One bore a white cloth embroidered at the edges with figures of animals; others bore on their broad backs trays with bowls and platters and knives and wooden spoons, which the dogs took and quickly laid on the trestle-tables. These were very low, low enough even for Bilbo to sit at comfortably. Beside them a pony pushed two low-seated benches with wide rush-bottoms and little short thick legs for Gandalf and Thorin, while at the far end he put Beorn's big black chair of the same sort … so soon they were all seated at Beorn's table, and the hall had not seen such a gathering for many a year.

There they had a supper, or a dinner, such as they had not had since they left the Last Homely House in the West and said good-bye to Elrond.

THE HOBBIT

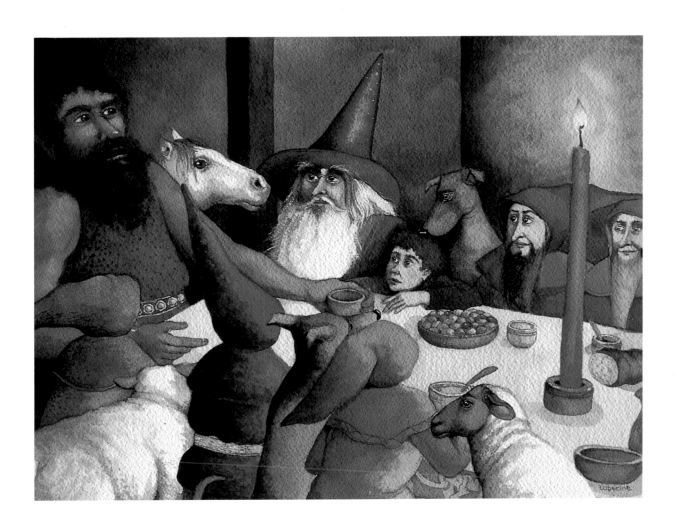

THE ATTACK OF THE WRAITHS

Ted Nasmith

Immediately, though everything else remained as before, dim and dark, the shapes became terribly clear. He was able to see beneath their black wrappings. There were five tall figures: two standing on the lip of the dell, three advancing. In their white faces burned keen and merciless eyes; under their mantles were long grey robes; upon their grey hairs were helms of silver; in their haggard hands were swords of steel. Their eyes fell on him and pierced him, as they rushed towards him. Desperate, he drew his own sword, and it seemed to him that it flickered red, as if it was a firebrand.

THE FELLOWSHIP OF THE RING

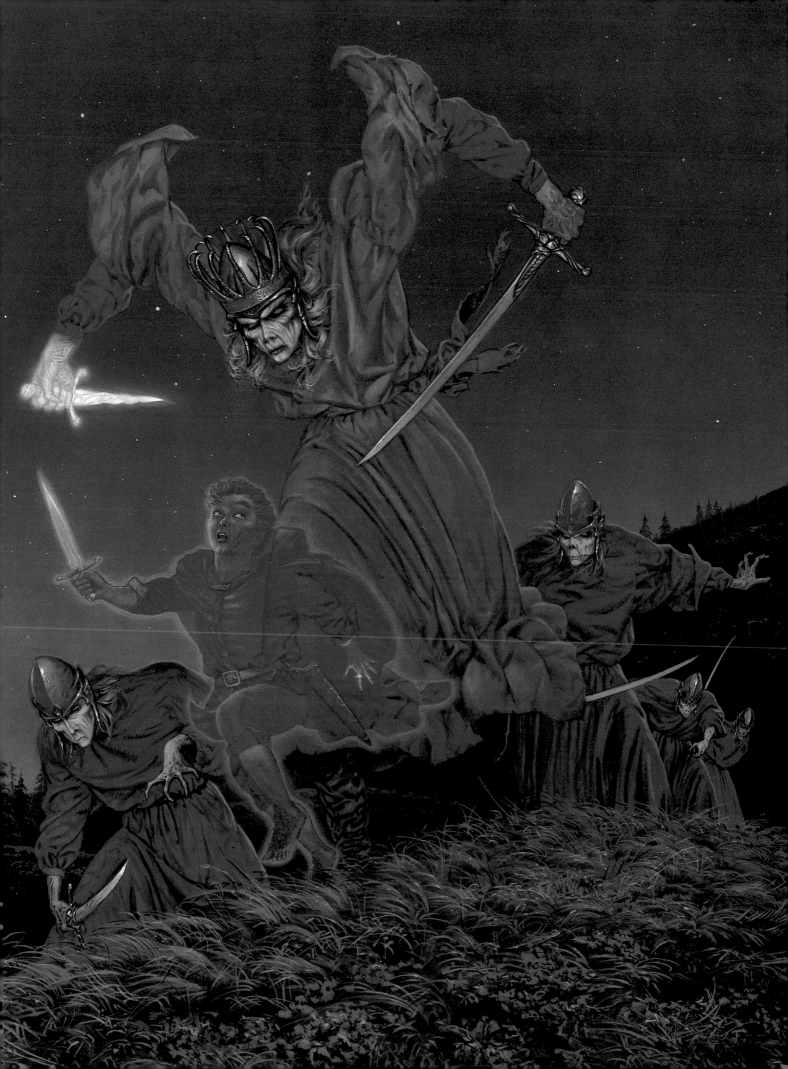

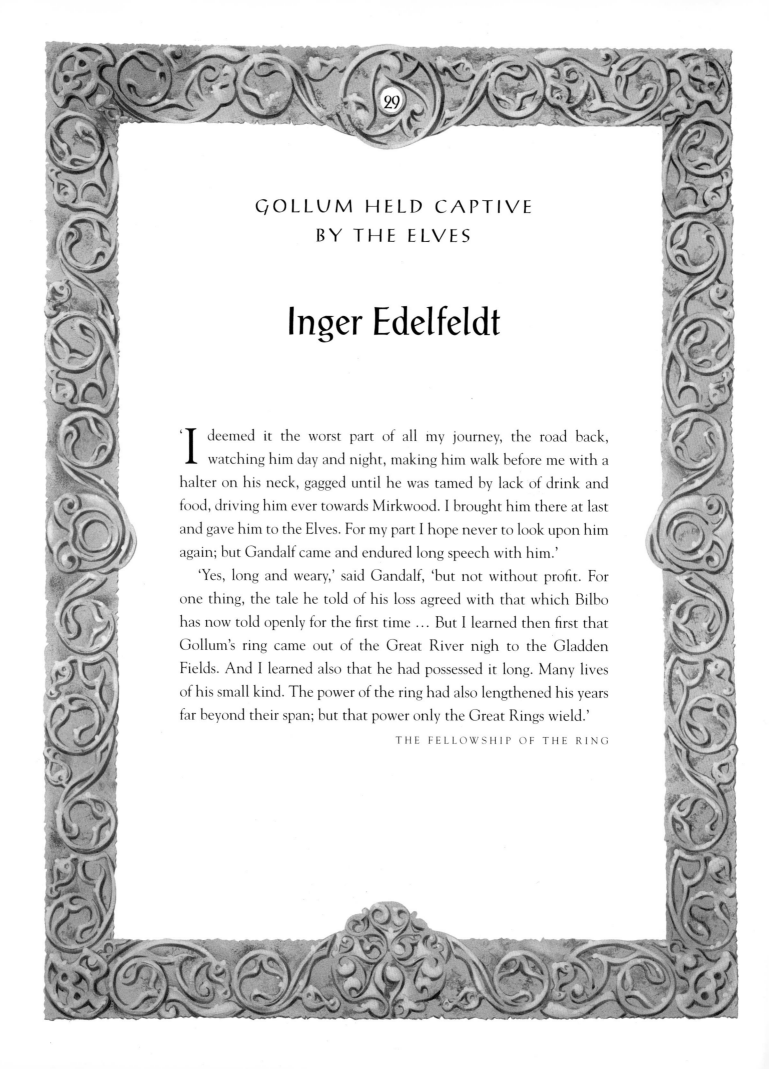

GOLLUM HELD CAPTIVE
BY THE ELVES

Inger Edelfeldt

'I deemed it the worst part of all my journey, the road back, watching him day and night, making him walk before me with a halter on his neck, gagged until he was tamed by lack of drink and food, driving him ever towards Mirkwood. I brought him there at last and gave him to the Elves. For my part I hope never to look upon him again; but Gandalf came and endured long speech with him.'

'Yes, long and weary,' said Gandalf, 'but not without profit. For one thing, the tale he told of his loss agreed with that which Bilbo has now told openly for the first time … But I learned then first that Gollum's ring came out of the Great River nigh to the Gladden Fields. And I learned also that he had possessed it long. Many lives of his small kind. The power of the ring had also lengthened his years far beyond their span; but that power only the Great Rings wield.'

THE FELLOWSHIP OF THE RING

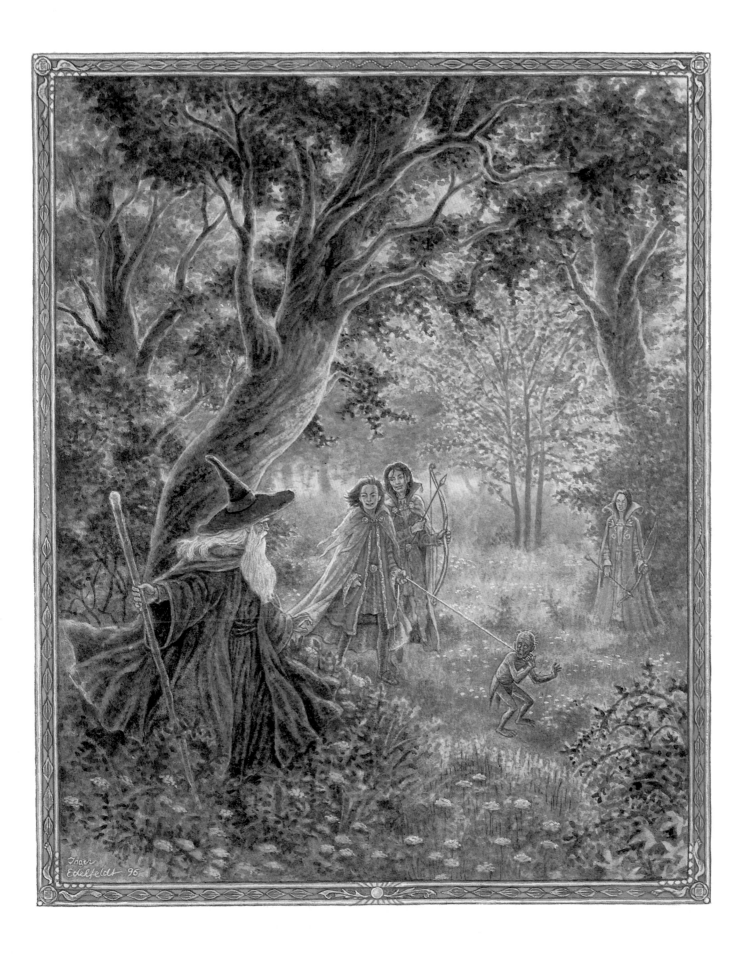

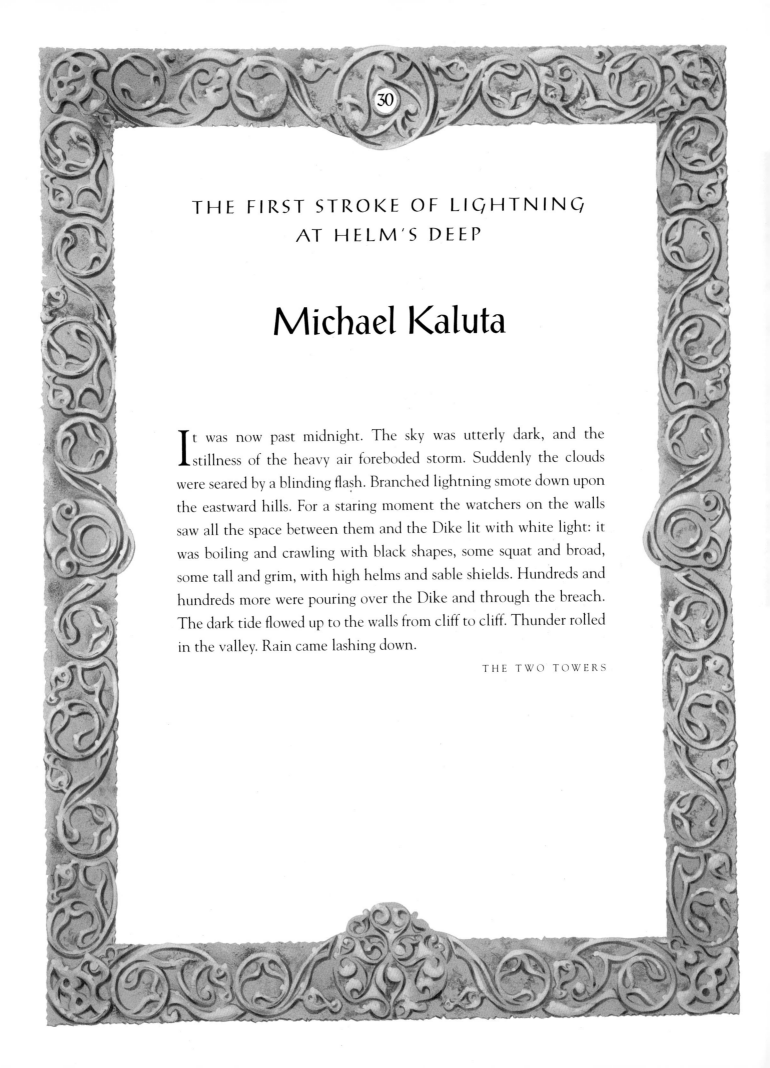

THE FIRST STROKE OF LIGHTNING
AT HELM'S DEEP

Michael Kaluta

It was now past midnight. The sky was utterly dark, and the stillness of the heavy air foreboded storm. Suddenly the clouds were seared by a blinding flash. Branched lightning smote down upon the eastward hills. For a staring moment the watchers on the walls saw all the space between them and the Dike lit with white light: it was boiling and crawling with black shapes, some squat and broad, some tall and grim, with high helms and sable shields. Hundreds and hundreds more were pouring over the Dike and through the breach. The dark tide flowed up to the walls from cliff to cliff. Thunder rolled in the valley. Rain came lashing down.

THE TWO TOWERS

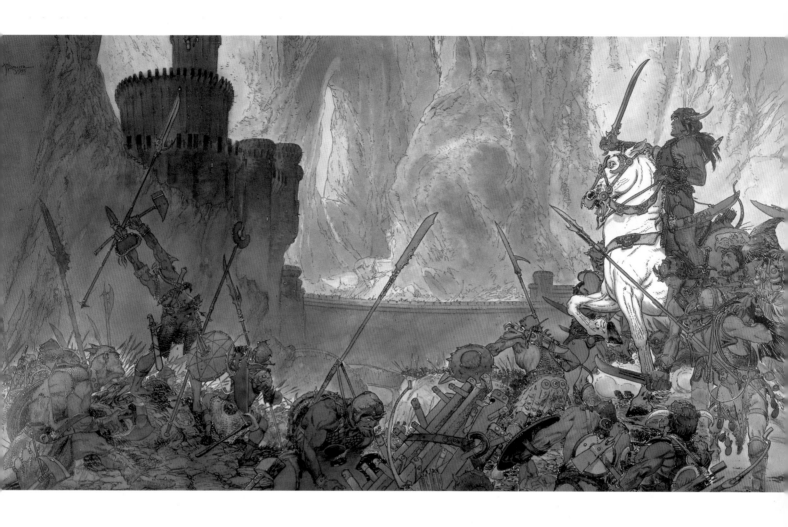

THE DEAD MARSHES

Alan Lee

Gollum laughed. 'The dead marshes, yes, yes: that is their names,' he cackled. 'You should not look in when the candles are lit.'

'Who are they? What are they?' asked Sam shuddering, turning to Frodo, who was now behind him.

'I don't know,' said Frodo in a dreamlike voice. 'But I have seen them too. In the pools when the candles were lit. They lie in all the pools, pale faces, deep deep under the dark water. I saw them: grim faces and evil, and noble faces and sad. Many faces proud and fair, and weeds in their silver hair. But all foul, all rotting, all dead. A fell light is in them.' Frodo hid his eyes in his hands. 'I know not who they are; but I thought I saw there Men and Elves, and Orcs beside them.'

THE TWO TOWERS

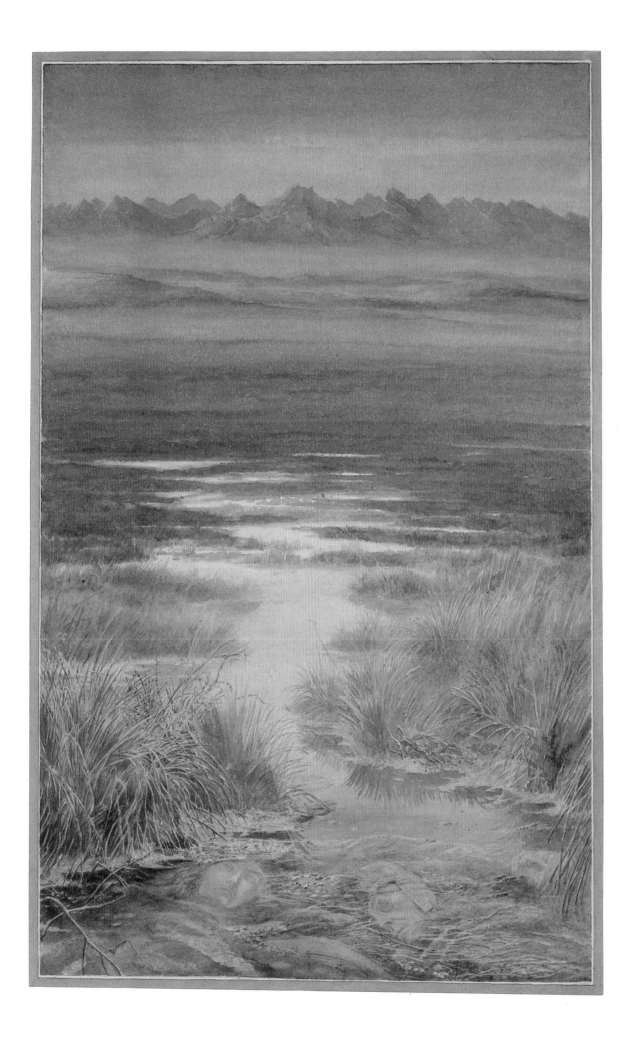

SAM AND SHELOB

Tony Galuidi

Hardly had Sam hidden the light of the star-glass when she came. A little way ahead and to his left he saw suddenly, issuing from a black hole of shadow under the cliff, the most loathly shape that he had ever beheld, horrible beyond the horror of an evil dream. Most like a spider she was, but huger than the great hunting beasts, and more terrible than they because of the evil purpose in her remorseless eyes. Those same eyes that he had thought daunted and defeated, there they were lit with a fell light again, clustering in her out-thrust head.

THE TWO TOWERS

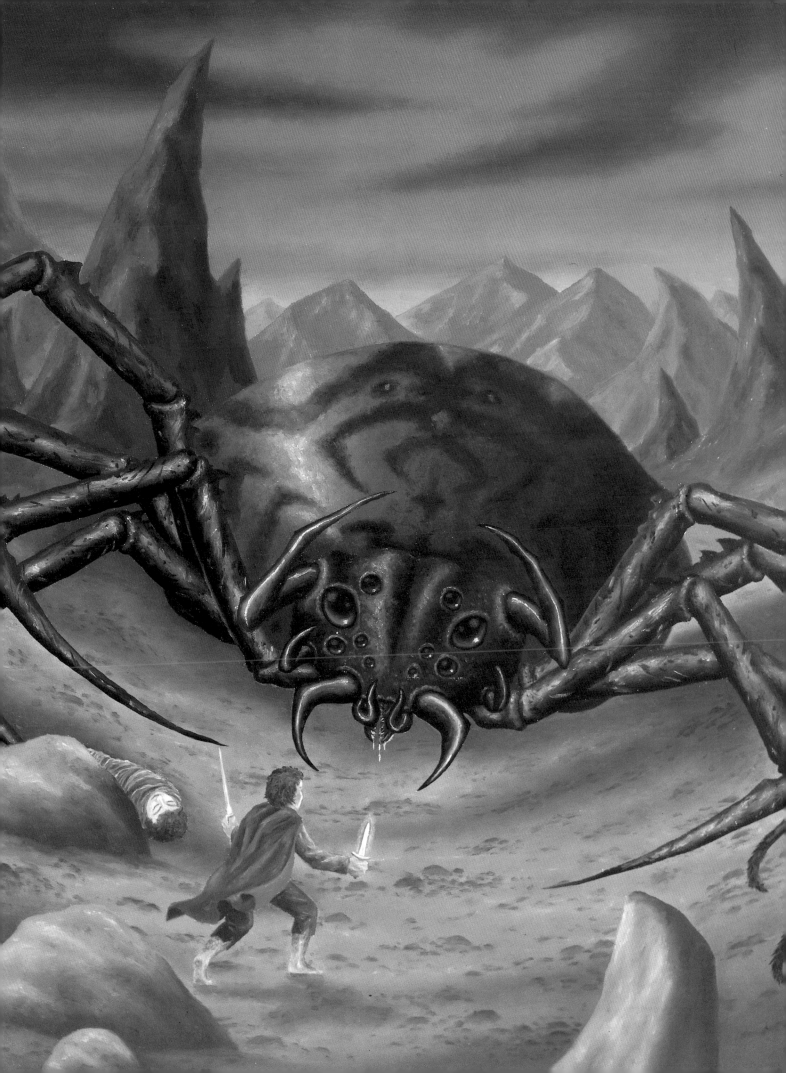

TREEBEARD AND THE ENTS

Timothy Ide

Bregalad, his eyes shining, swung into the line beside Treebeard. The old Ent now took the hobbits back, and set them on his shoulders again, and so they rode proudly at the head of the singing company with beating hearts and heads held high. Though they had expected something to happen eventually, they were amazed at the change that had come over the Ents. It seemed now as sudden as the bursting of a flood that had long been held back by a dike.

THE TWO TOWERS

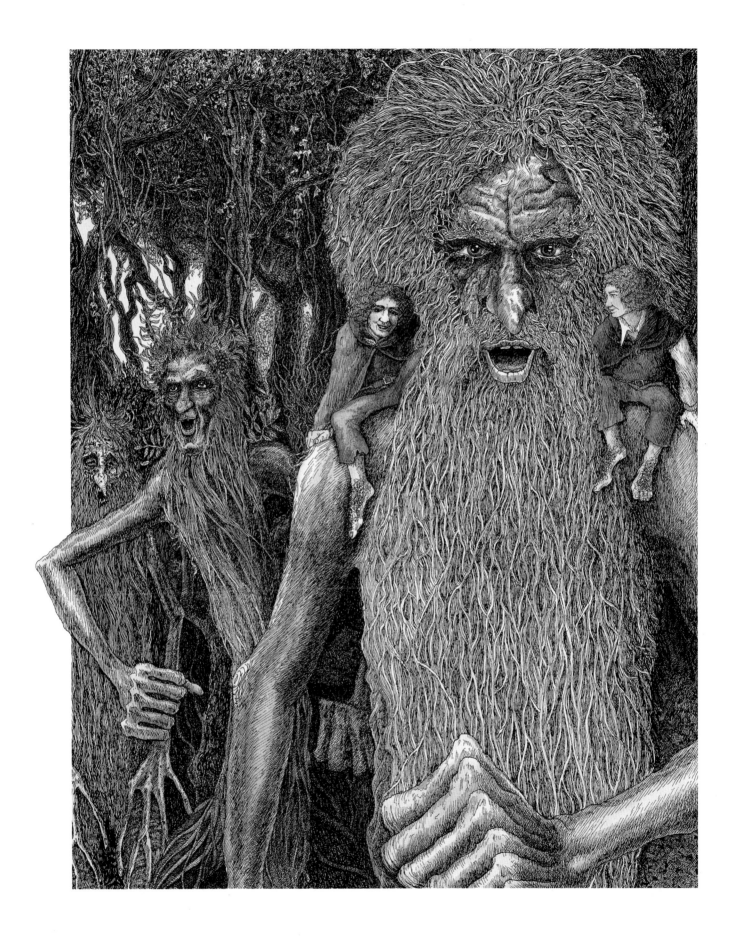

THE BATTLE OF THE HORNBURG

Cor Blok

The sky now was quickly clearing and the sinking moon was shining brightly. But the light brought little hope to the Riders of the Mark. The enemy before them seemed to have grown rather than diminished, and still more were pressing up from the valley through the breach. The sortie upon the Rock gained only a brief respite. The assault on the gates was redoubled. Against the Deeping Wall the hosts of Isengard roared like a sea. Orcs and hillmen swarmed about its feet from end to end. Ropes with grappling hooks were hurled over the parapet faster than men could cut them or fling them back. Hundreds of long ladders were lifted up. Many were cast down in ruin, but many more replaced them, and Orcs sprang up them like apes in the dark forests of the South. Before the wall's foot the dead and broken were piled like shingle in a storm; ever higher rose the hideous mounds, and still the enemy came on.

THE TWO TOWERS

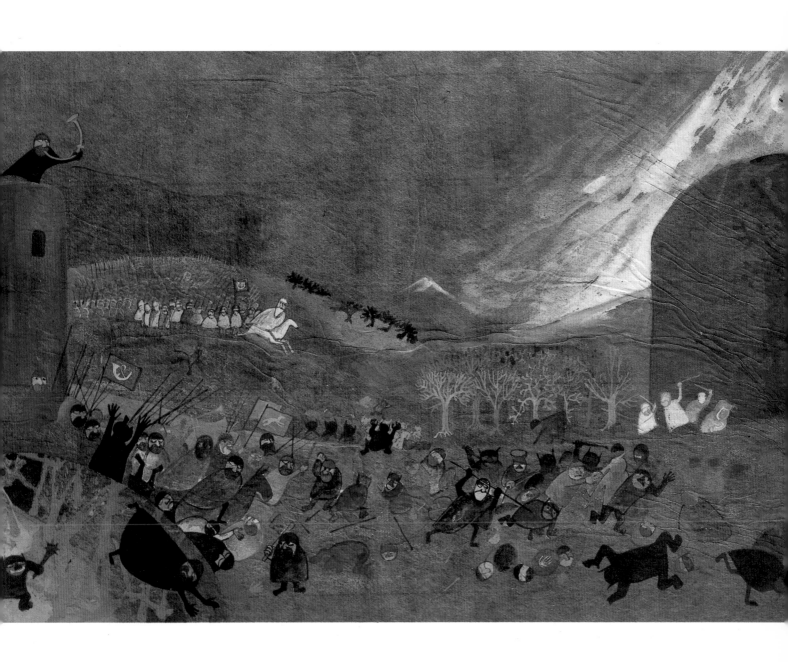

THE NAZGÛL

Ted Nasmith

It was a winged creature: if a bird, then greater than all other birds, and it was naked, and neither quill nor feather did it bear, and its vast pinions were as webs of hide between horned fingers: and it stank. A creature of an older world maybe it was, whose kind, lingering in forgotten mountains cold beneath the Moon, outstayed their day, and in hideous eyrie bred this last untimely brood, apt to evil. And the Dark Lord took it, and nursed it with fell meats, until it grew beyond the measure of all other things that fly; and he gave it to his servant to be his steed.

THE RETURN OF THE KING

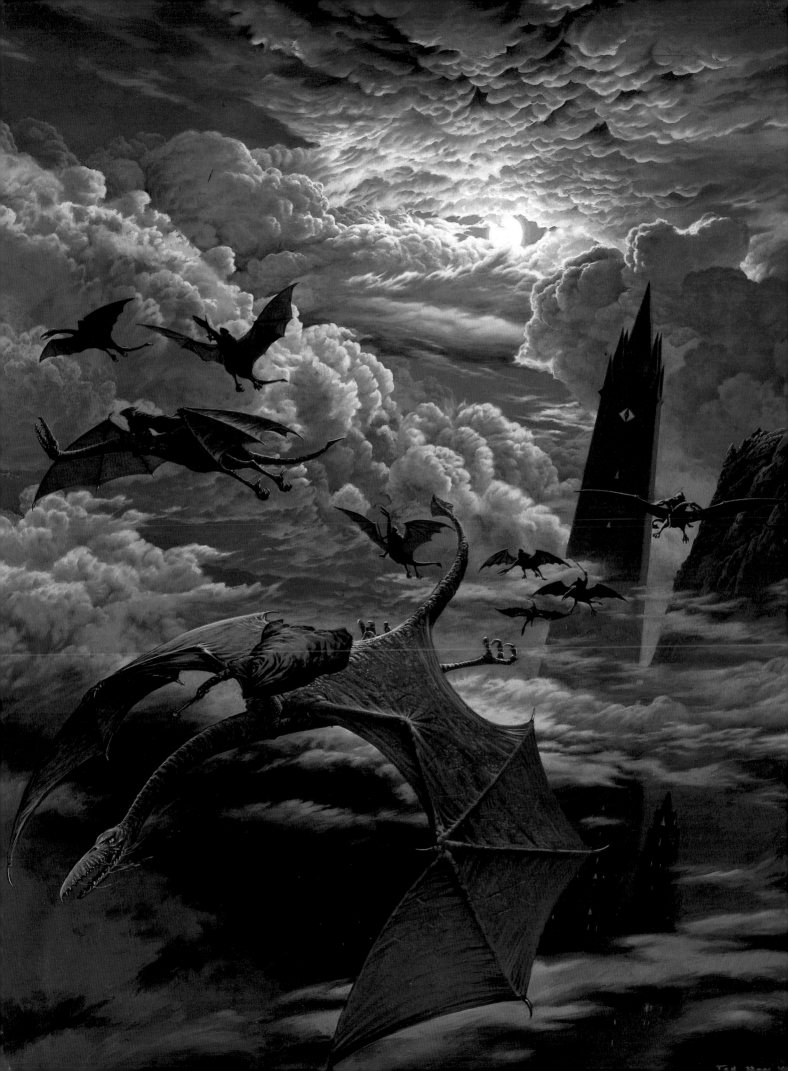

THE LORD OF THE NAZGÛL ENTERS THE GATES OF GONDOR

Fletcher

In rode the Lord of the Nazgûl. A great black shape against the fires beyond he loomed up, grown to a vast menace of despair. In rode the Lord of the Nazgûl, under the archway that no enemy ever yet had passed, and all fled before his face …

'You cannot enter here,' said Gandalf, and the huge shadow halted. 'Go back to the abyss prepared for you! Go back! Fall into the nothingness that awaits you and your Master. Go!'

THE RETURN OF THE KING

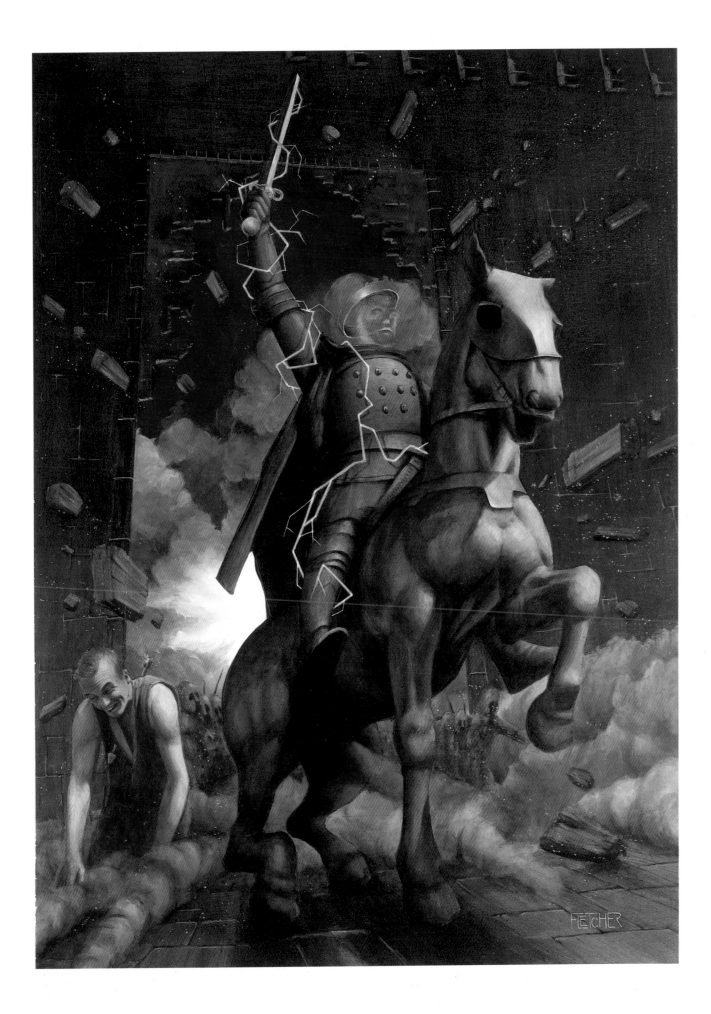

UNGOLIANTË AND MELKOR

John Howe

In a deep cleft of the mountains she dwelt, and took shape as it were a spider of monstrous form, sucking up all such light as she could find, or that strayed over the walls of Valinor, and she spun it forth again in black webs of strangling gloom, until no light more could come to her abode, and she was famished.

It may well be that Melkor, if none other, knew of her being and her abode … he sought her out, and demanded her aid in his revenge. But she was loath to dare the perils of Valinor and the great wrath of the gods, and would not stir from her hiding until Melkor had vowed to render her a reward that should heal the gnawing of her hunger and hatred.

MORGOTH'S RING

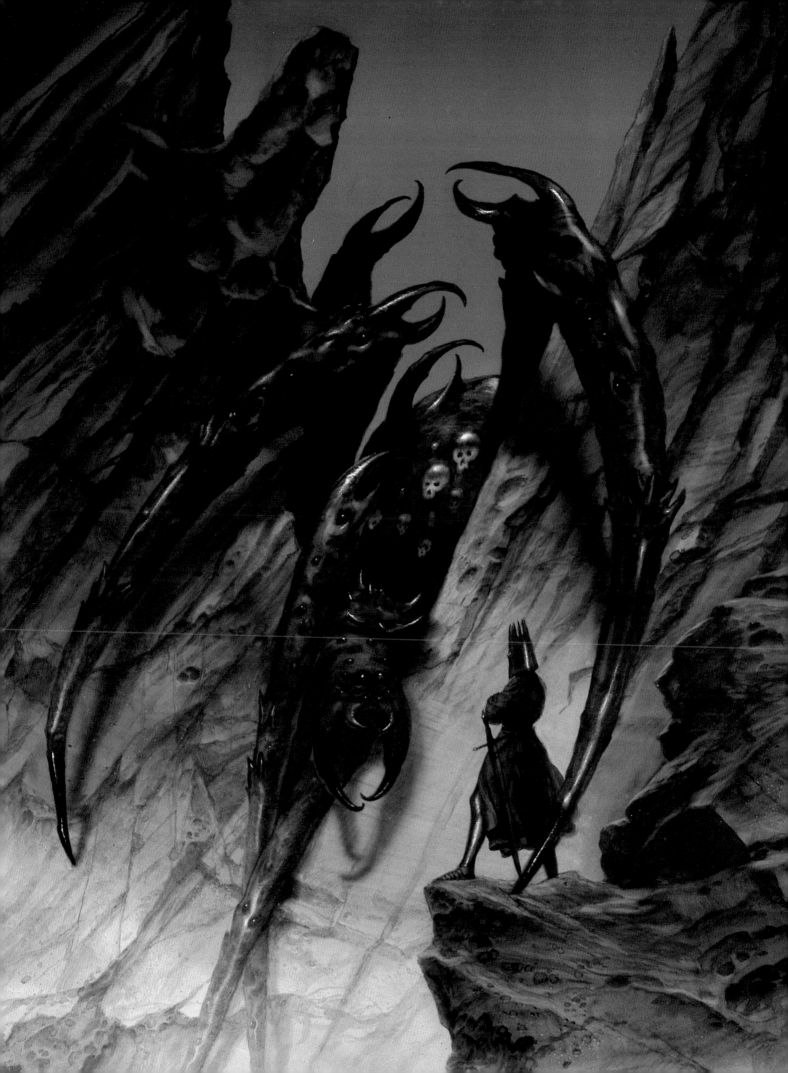

A CONSPIRACY UNMASKED

Carol Emery Phenix

Frodo opened his mouth and shut it again. His look of surprise was so comical that they laughed. 'Dear old Frodo!' said Pippin. 'Did you really think you had thrown dust in all our eyes? You have not been nearly careful or clever enough for that! You have obviously been planning to go and saying farewell to all your haunts all this year since April. We have constantly heard you muttering: "Shall I ever look down into that valley again, I wonder," and things like that. And pretending that you had come to the end of your money, and actually selling your beloved Bag End to those Sackville-Bagginses! And all those close talks with Gandalf!'

THE FELLOWSHIP OF THE RING

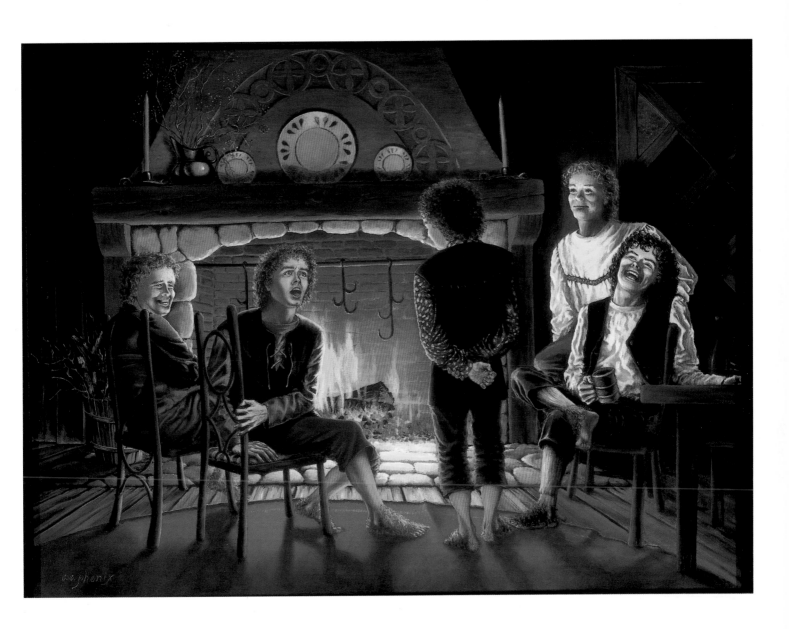

THE BATTLE OF THE FIVE ARMIES

Capucine Mazille

Panic came upon the Goblins; and even as they turned to meet this new attack, the elves charged again with renewed numbers. Already many of the goblins were flying back down the river to escape from the trap; and many of their own wolves were turning upon them and rending the dead and the wounded. Victory seemed at hand, when a cry rang out on the heights above.

THE HOBBIT

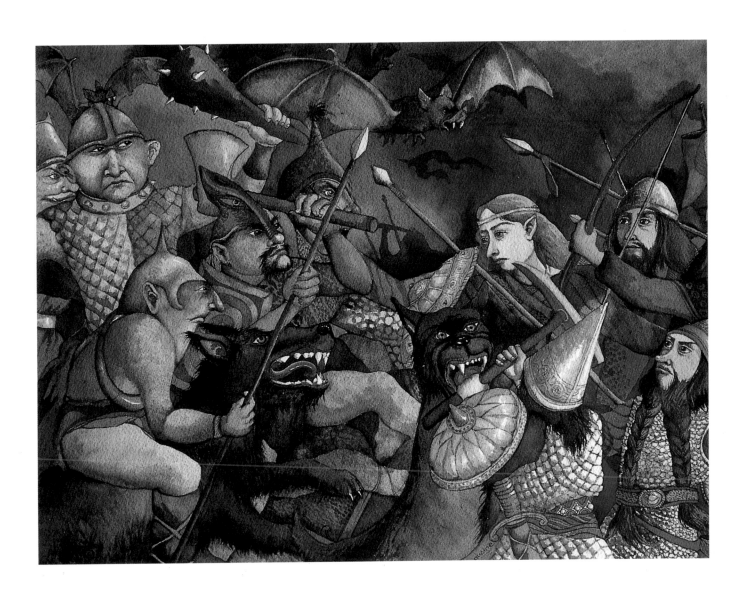

BILBO FLIES ON EAGLE'S WINGS

Gerd Renshoff and Ron Ploeg

This time he was allowed to climb on to an eagle's back and cling between his wings. The air rushed over him and he shut his eyes … The sun was still close to the eastern edge of things. The morning was cool, and mists were in the valleys and hollows and twined here and there about the peaks and pinnacles of the hills. Bilbo opened an eye to peep and saw that the birds were already high up and the world was far away, and the mountains were falling back behind them into the distance. He shut his eyes again and held on even tighter.

THE HOBBIT

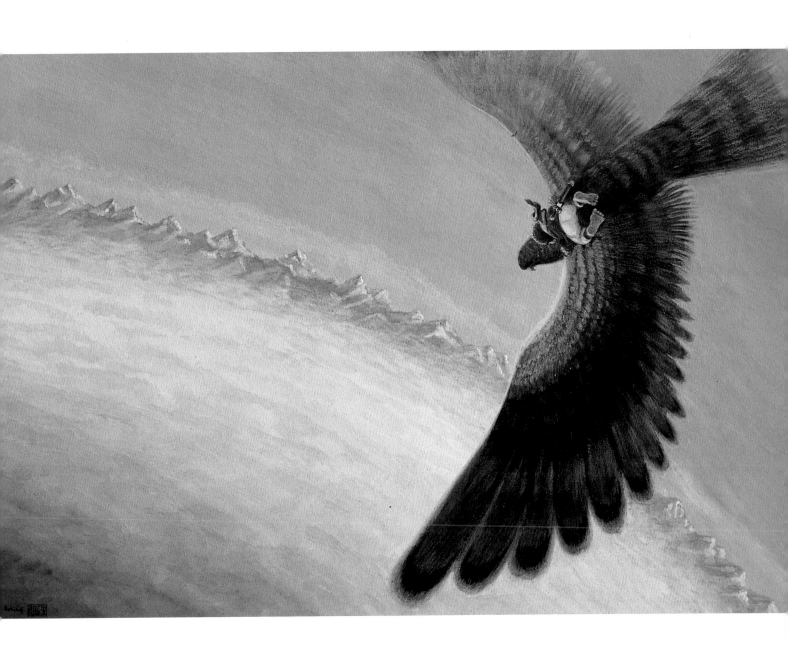

THE MÛMAK OF HARAD

Cor Blok

To his astonishment and terror, and lasting delight, Sam saw a vast shape crash out of the trees and come careering down the slope. Big as a house, much bigger than a house, it looked to him, a grey-clad moving hill. Fear and wonder, maybe, enlarged him in the hobbit's eyes, but the Mûmak of Harad was indeed a beast of vast bulk, and the like of him does not walk now in Middle-earth; his kin that live still in latter days are but memories of his girth and majesty. On he came, straight towards the watchers, and then swerved aside in the nick of time, passing only a few yards away, rocking the ground beneath their feet: his great legs like trees, enormous sail-like ears spread out, long snout upraised like a huge serpent about to strike, his small red eyes raging.

THE TWO TOWERS

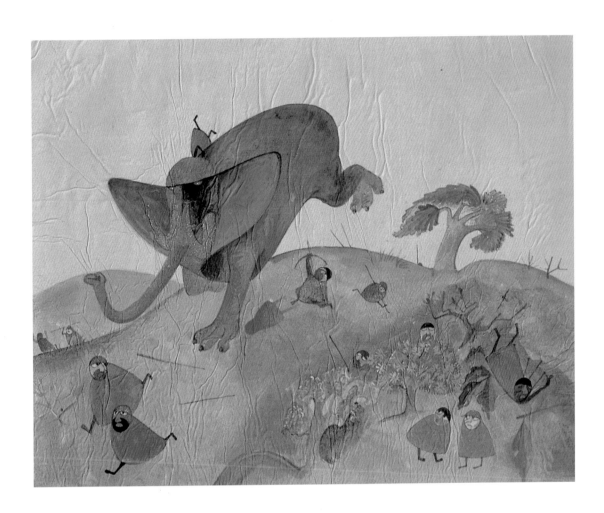

THE GATE OF MORIA

Lode Claes

The Moon now shone upon the grey face of the rock; but they could see nothing else for a while. Then slowly on the surface, where the wizard's hands had passed, faint lines appeared, like slender veins of silver running in the stone. At first they were no more than pale gossamer-threads, so fine that they only twinkled fitfully where the Moon caught them, but steadily they grew broader and clearer, until their design could be guessed.

At the top, as high as Gandalf could reach, was an arch of interlacing letters in an Elvish character. Below, though the threads were in places blurred or broken, the outline could be seen of an anvil and a hammer surmounted by a crown with seven stars. Beneath these again were two trees, each bearing crescent moons. More clearly than all else there shone forth in the middle of the door a single star with many rays.

THE FELLOWSHIP OF THE RING

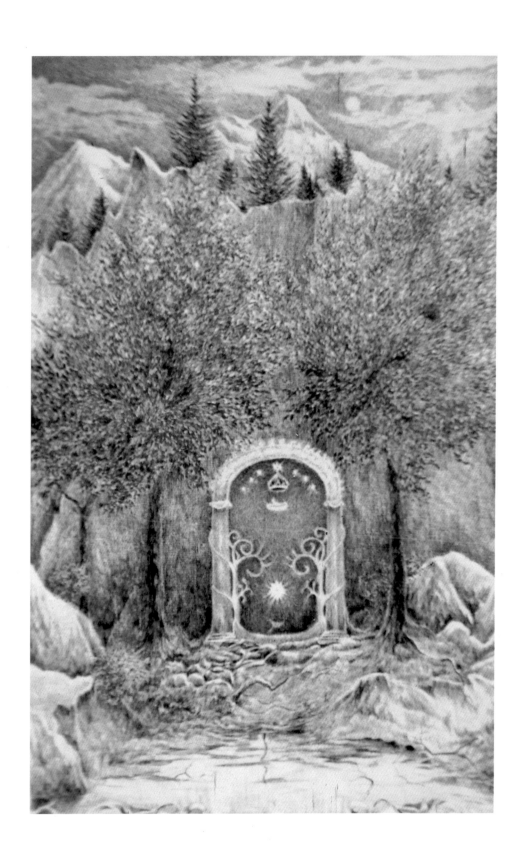

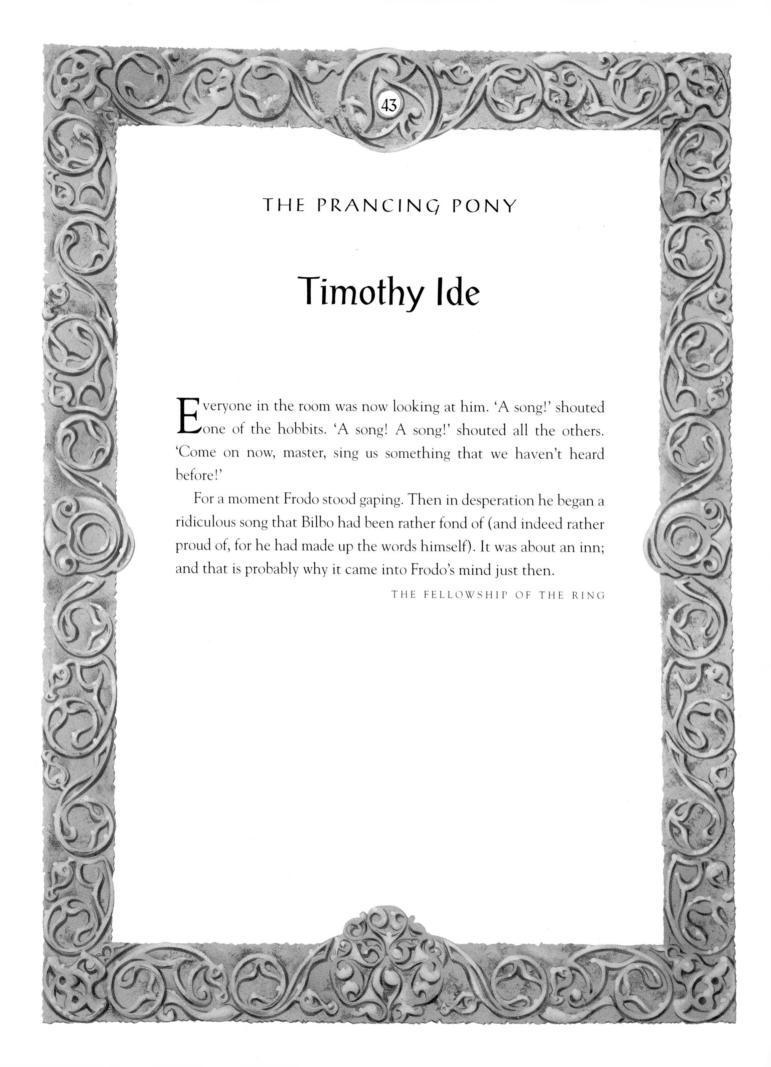

THE PRANCING PONY

Timothy Ide

Everyone in the room was now looking at him. 'A song!' shouted one of the hobbits. 'A song! A song!' shouted all the others. 'Come on now, master, sing us something that we haven't heard before!'

For a moment Frodo stood gaping. Then in desperation he began a ridiculous song that Bilbo had been rather fond of (and indeed rather proud of, for he had made up the words himself). It was about an inn; and that is probably why it came into Frodo's mind just then.

THE FELLOWSHIP OF THE RING

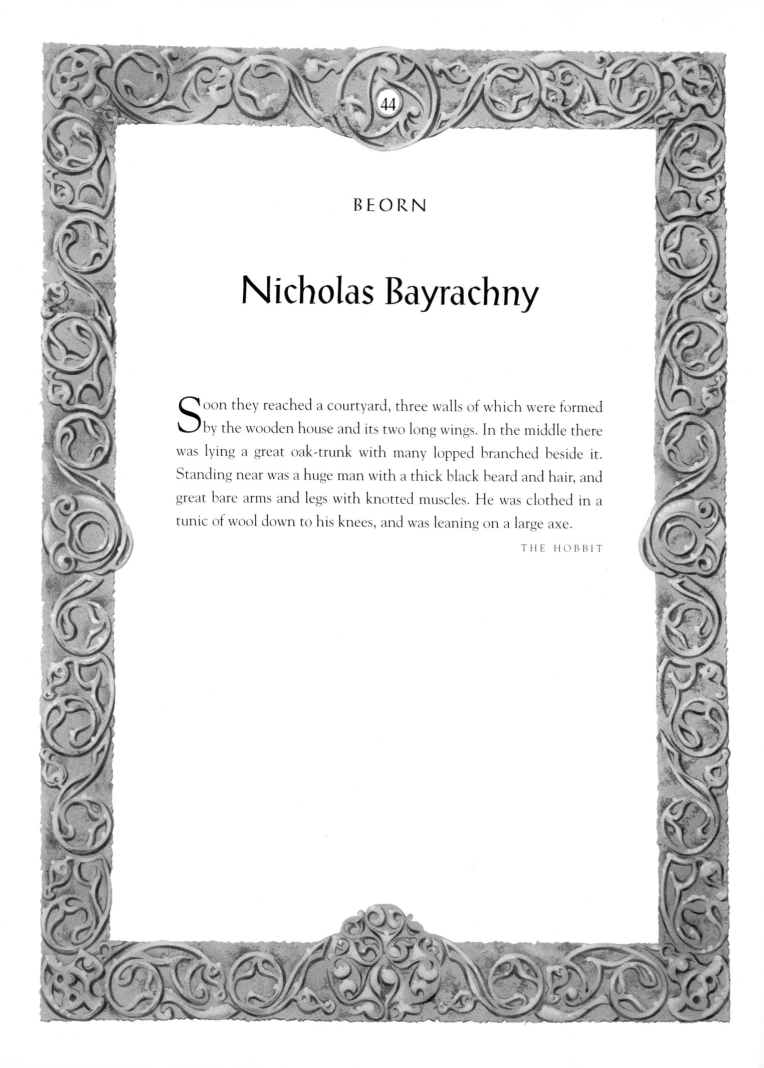

BEORN

Nicholas Bayrachny

Soon they reached a courtyard, three walls of which were formed by the wooden house and its two long wings. In the middle there was lying a great oak-trunk with many lopped branched beside it. Standing near was a huge man with a thick black beard and hair, and great bare arms and legs with knotted muscles. He was clothed in a tunic of wool down to his knees, and was leaning on a large axe.

THE HOBBIT

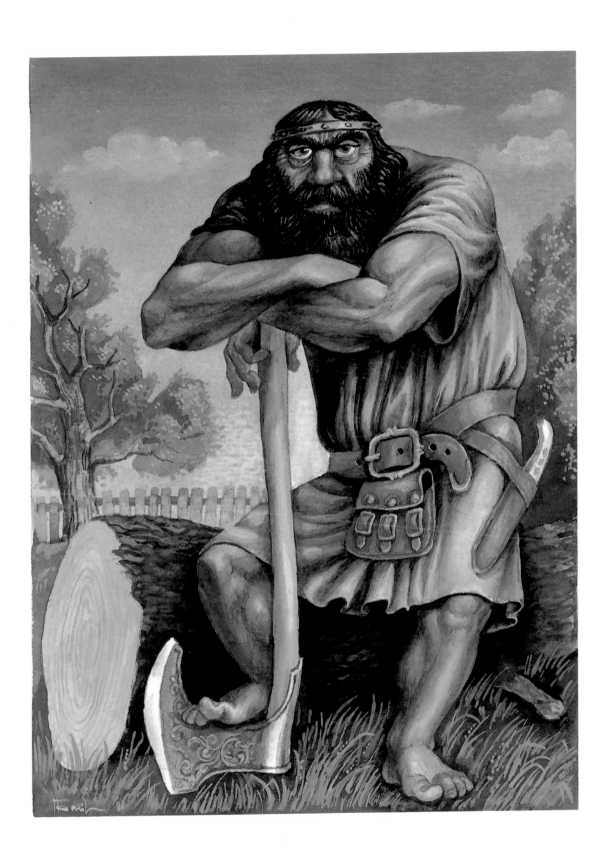

TWO ORCS

Alan Lee

'Garn!' said Shagrat. 'She's got more than one poison. When she's hunting, she just gives 'em a dab in the neck and they go as limp as boned fish, and then she has her way with them. D'you remember old Ufthak? We lost him for days. Then we found him in a corner; hanging up he was, but he was wide awake and glaring. How we laughed! She'd forgotten him, maybe, but we didn't touch him – no good interfering with Her. Nar – this little filth, he'll wake up, in a few hours; and beyond feeling a bit sick for a bit, he'll be all right … '

'And what's going to happen to him,' laughed Gorbag. 'We can tell him a few stories at any rate, if we can't do anything else.'

THE TWO TOWERS

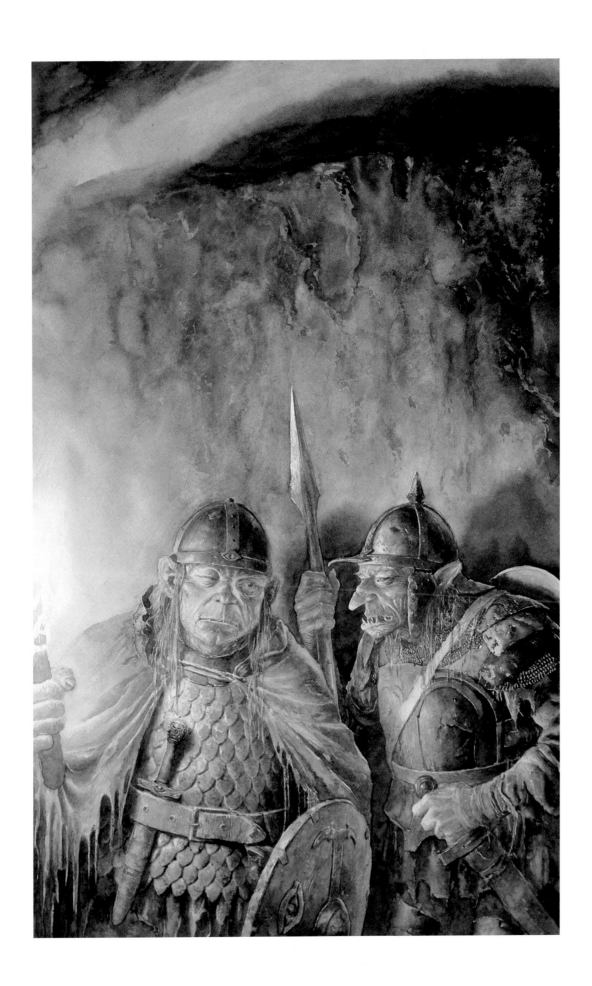

A HOBBIT DWELLING

John Howe

In a hole in the ground there lived a hobbit. Not a nasty, dirty wet hole, filled with the ends of worms and an oozy smell, nor yet a dry, bare, sandy hole with nothing in it to sit down on or to eat: it was a hobbit-hole, and that means comfort.

It had a perfectly round door like a porthole, painted green, with a shiny yellow brass knob in the exact middle. The door opened on to a tube-shaped hall like a tunnel: a very comfortable tunnel without smoke, with panelled walls, and floors tiled and carpeted, provided with polished chairs and lots and lots of pegs for hats and coats – the hobbit was fond of visitors.

THE HOBBIT

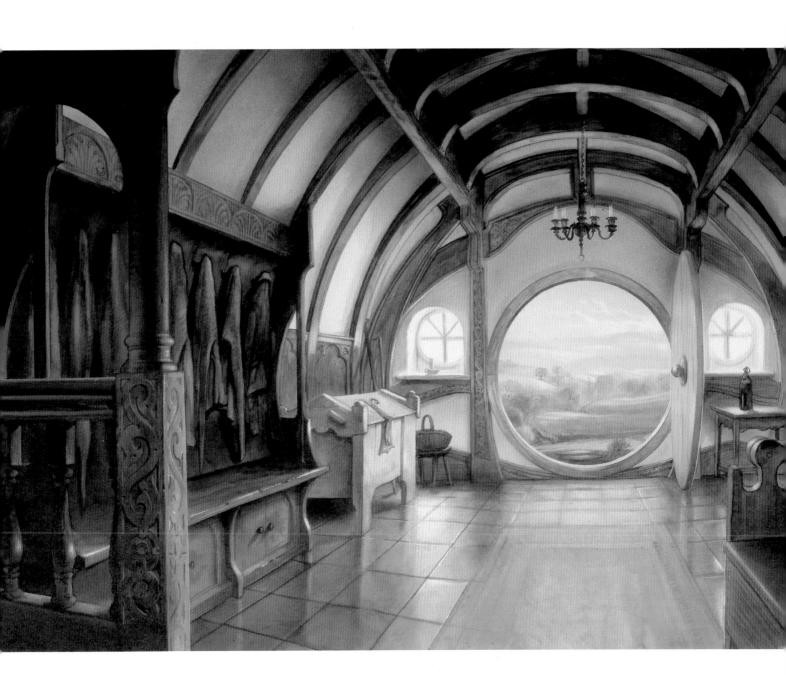

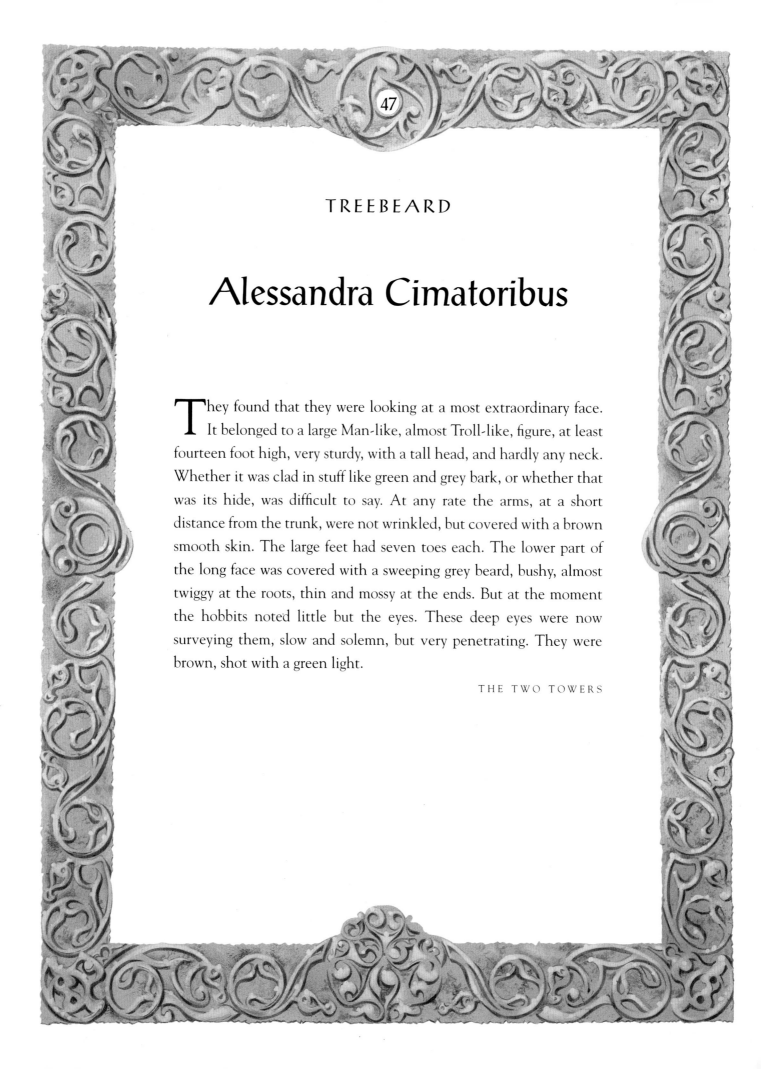

TREEBEARD

Alessandra Cimatoribus

They found that they were looking at a most extraordinary face. It belonged to a large Man-like, almost Troll-like, figure, at least fourteen foot high, very sturdy, with a tall head, and hardly any neck. Whether it was clad in stuff like green and grey bark, or whether that was its hide, was difficult to say. At any rate the arms, at a short distance from the trunk, were not wrinkled, but covered with a brown smooth skin. The large feet had seven toes each. The lower part of the long face was covered with a sweeping grey beard, bushy, almost twiggy at the roots, thin and mossy at the ends. But at the moment the hobbits noted little but the eyes. These deep eyes were now surveying them, slow and solemn, but very penetrating. They were brown, shot with a green light.

THE TWO TOWERS

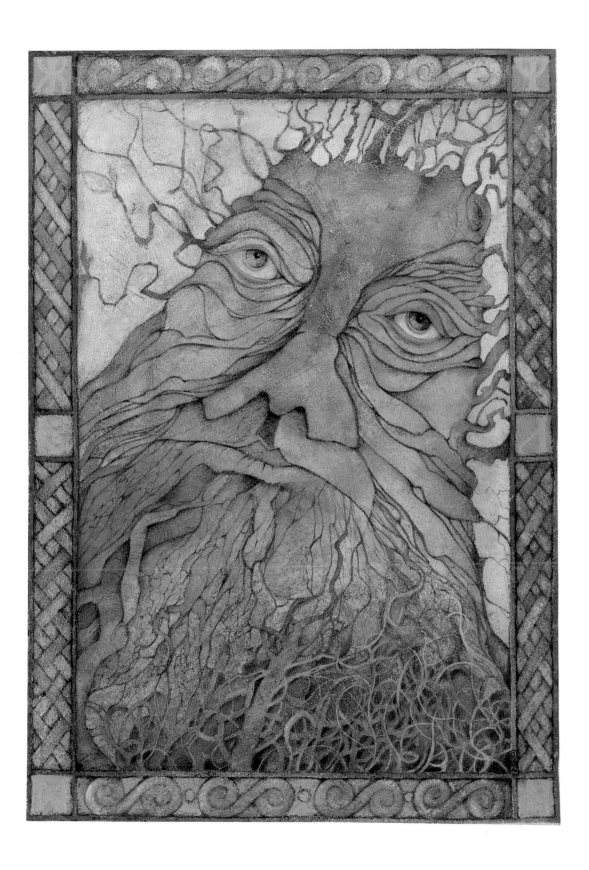

NO WAY DOWN

Ted Nasmith

The hobbits stood now on the brink of a tall cliff, bare and bleak, its feet wrapped in mist; and behind them rose the broken highlands crowned with drifting cloud. A chill wind blew from the East. Night was gathering over the shapeless lands before them; the sickly green of them was fading to a sullen brown. Far away to the right the Anduin, that had gleamed fitfully in sun-breaks during the day, was now hidden in shadow. But their eyes did not look beyond the River, back to Gondor, to their friends, to the lands of Men. South and east they stared to where, at the edge of the oncoming night, a dark line hung, like distant mountains of motionless smoke. Every now and again a tiny red gleam far away flickered upwards on the rim of earth and sky.

THE TWO TOWERS

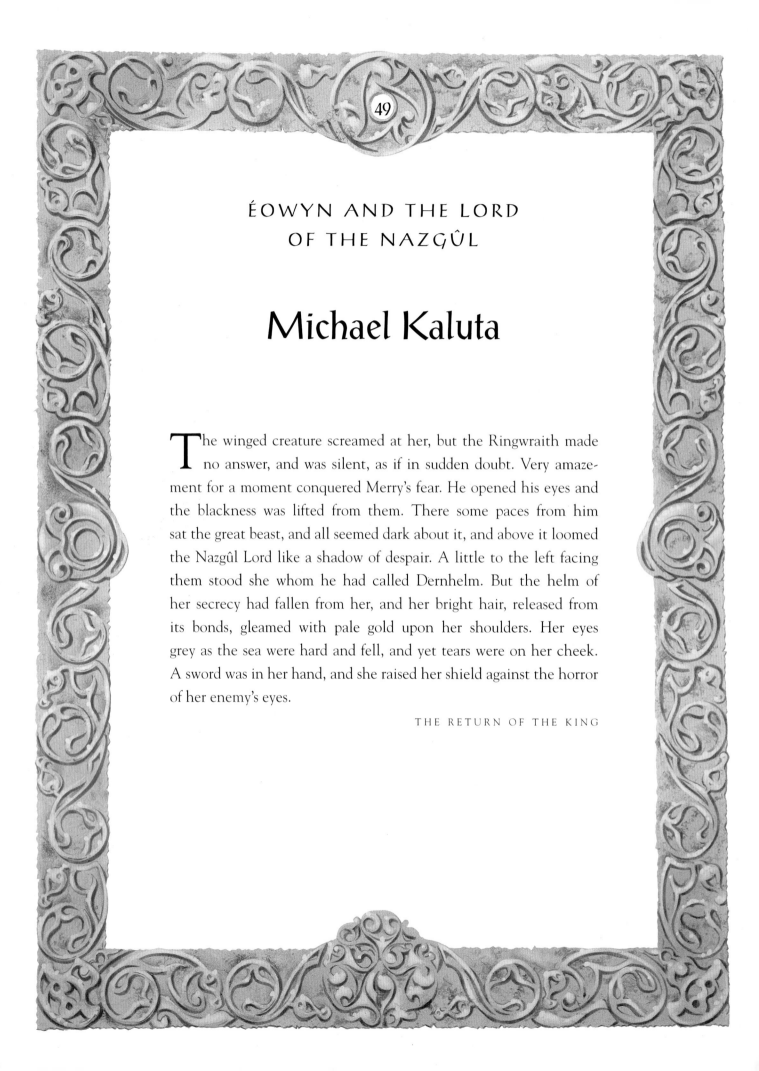

ÉOWYN AND THE LORD
OF THE NAZGÛL

Michael Kaluta

The winged creature screamed at her, but the Ringwraith made no answer, and was silent, as if in sudden doubt. Very amazement for a moment conquered Merry's fear. He opened his eyes and the blackness was lifted from them. There some paces from him sat the great beast, and all seemed dark about it, and above it loomed the Nazgûl Lord like a shadow of despair. A little to the left facing them stood she whom he had called Dernhelm. But the helm of her secrecy had fallen from her, and her bright hair, released from its bonds, gleamed with pale gold upon her shoulders. Her eyes grey as the sea were hard and fell, and yet tears were on her cheek. A sword was in her hand, and she raised her shield against the horror of her enemy's eyes.

THE RETURN OF THE KING

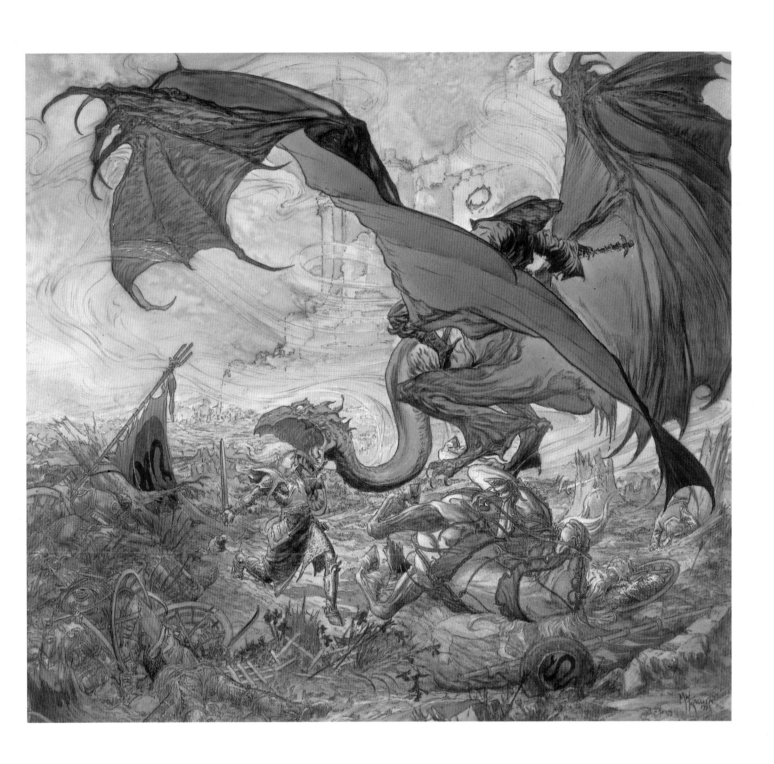

SMAUG

John Howe

There he lay, a vast red-golden dragon, fast asleep; a thrumming came from his jaws and nostrils, and wisps of smoke, but his fires were low in slumber. Beneath him, under all his limbs and his huge coiled tail, and about him on all sides stretching away across the unseen floors, lay countless piles of precious things, gold wrought and unwrought, gems and jewels, and silver red-stained in the ruddy light.

Smaug lay, with wings folded like an immeasurable bat, turned partly on one side, so that the hobbit could see his underparts and his long pale belly crusted with gems and fragments of gold from his long lying on his costly bed.

THE HOBBIT

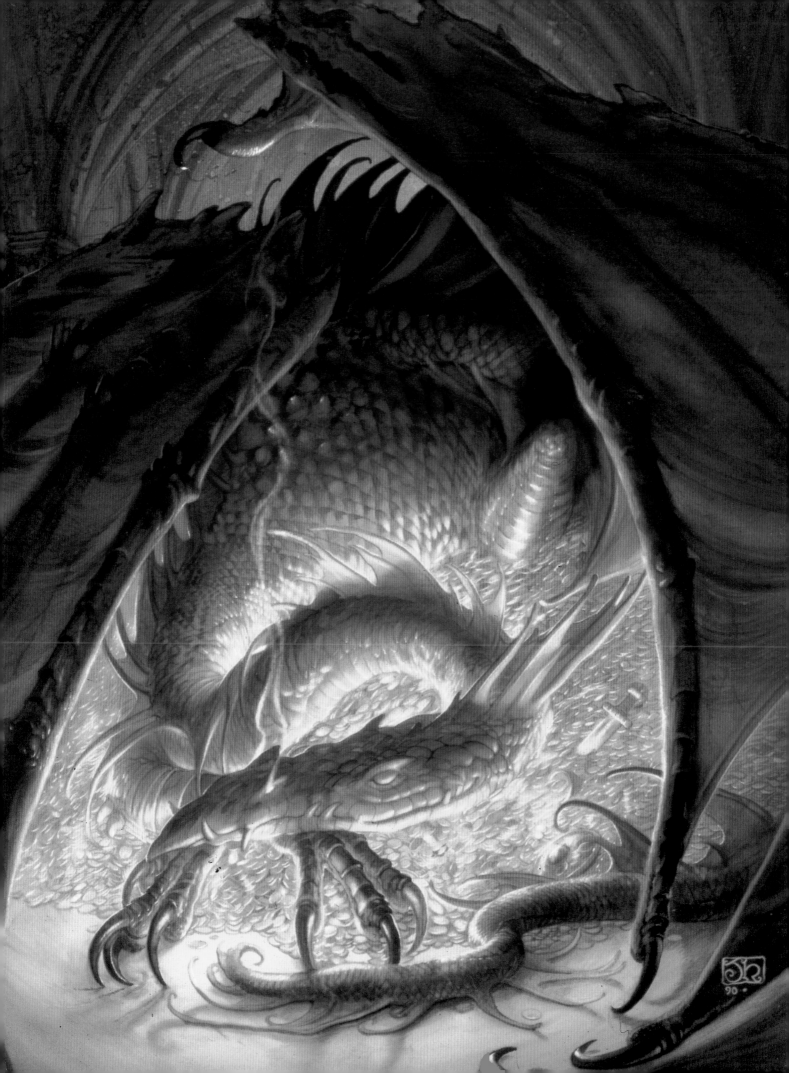

ROUGH STEPS GOING UP THE LONELY MOUNTAIN

Gerd Renshoff and Ron Ploeg

But at last unexpectedly they found what they were seeking. Fili and Kili and the hobbit went back one day down the valley and scrambled among the tumbled rocks at its southern corner. About midday, creeping behind a great stone that stood alone like a pillar, Bilbo came on what looked like rough steps going upwards. Following these excitedly he and the dwarves found traces of a narrow track, often lost, often rediscovered, that wandered on to the top of the southern ridge and brought them at last to a narrower ledge, which turned north across the face of the Mountain.

THE HOBBIT

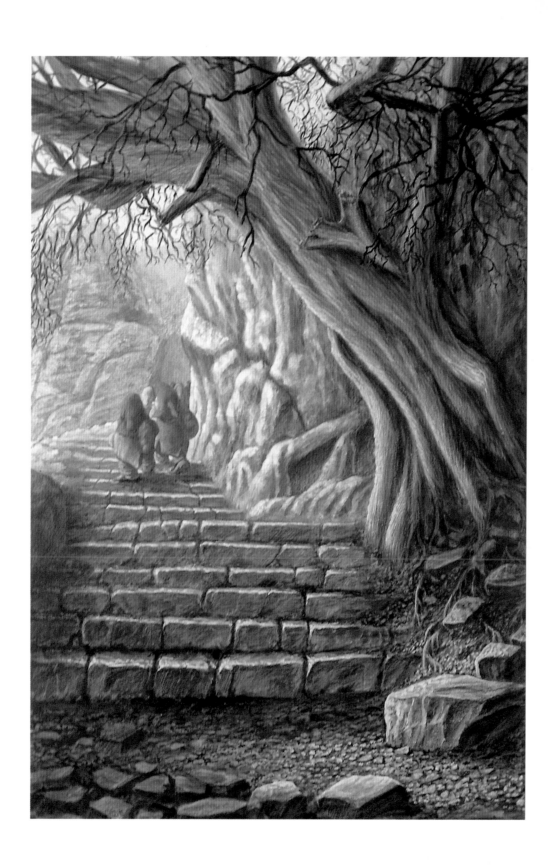

THE GAME OF RIDDLES

Cor Blok

It cannot be seen, cannot be felt,
Cannot be heard, cannot be smelt.
It lies behind stars and under hills,
* And empty holes it fills.*
It comes first and follows after,
* Ends life, kills laughter.*

Unfortunately for Gollum Bilbo had heard that sort of thing before; and the answer was all round him any way. 'Dark!' he said without even scratching his head or putting on his thinking cap.

THE HOBBIT

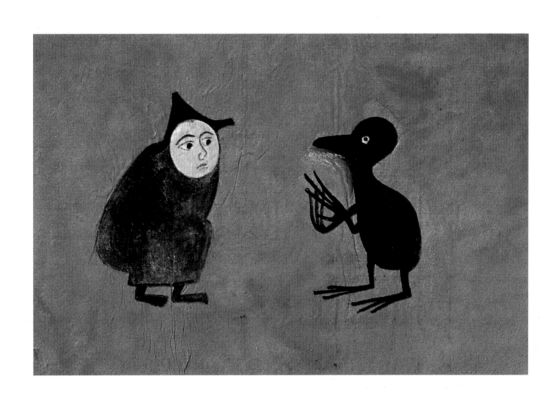

THE BLACK GATE IS CLOSED

Alan Lee

Gollum rose slowly and crawled insect-like to the lip of the hollow ... 'More Men going to Mordor,' he said in a low voice. 'Dark faces. We have not seen Men like these before, no, Sméagol has not. They are fierce. They have black eyes, and long black hair, and gold rings in their ears; yes, lots of beautiful gold. And some have red paint on their cheeks, and red cloaks; and their flags are red, and the tips of their spears; and they have round shields, yellow and black with big spikes. Not nice; very cruel wicked Men they look. Almost as bad as Orcs, and much bigger. Sméagol thinks they have come out of the South beyond the Great River's end: they came up that road. They have passed on to the Black Gate; but more may follow. Always more people coming to Mordor. One day all the peoples will be inside.'

THE TWO TOWERS

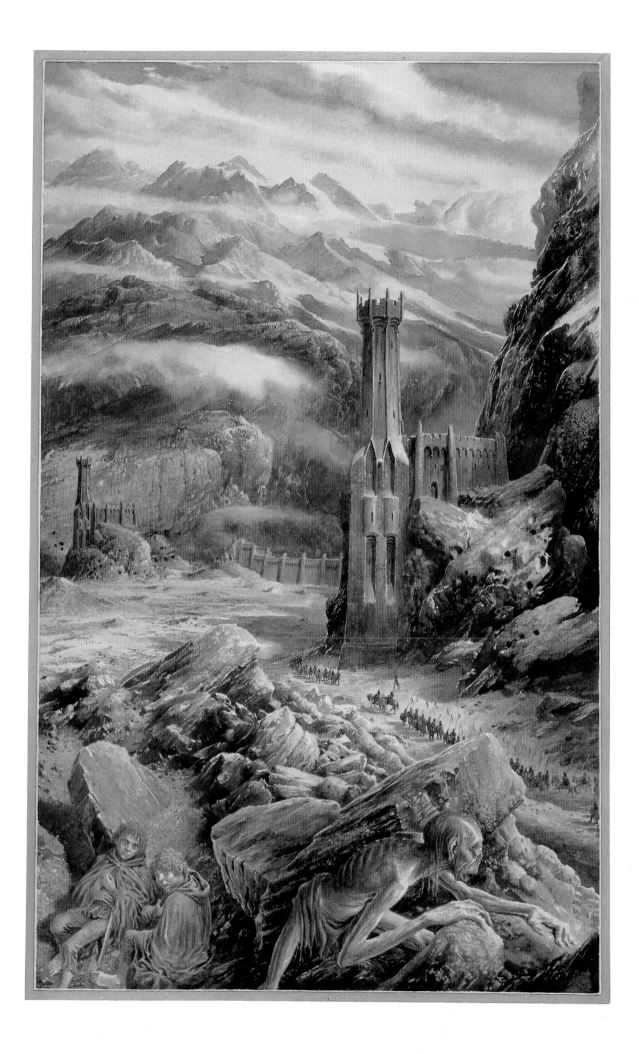

DEPARTURE AT THE GREY HAVENS

Ted Nasmith

The Círdan led them to the Havens, and there was a white
ship lying, and upon the quay beside a great grey horse stood a
figure robed all in white awaiting them. As he turned and came
towards them Frodo saw that Gandalf now wore openly upon his
hand the Third Ring, Narya the Great, and the stone upon it was red
as fire. Then those who were to go were glad, for they knew that
Gandalf also would take ship with them …

'Well, here at last, dear friends, on the shores of the Sea comes
the end of our fellowship in Middle-earth. Go in Peace! I will not say:
do not weep; for not all tears are an evil.'

THE RETURN OF THE KING

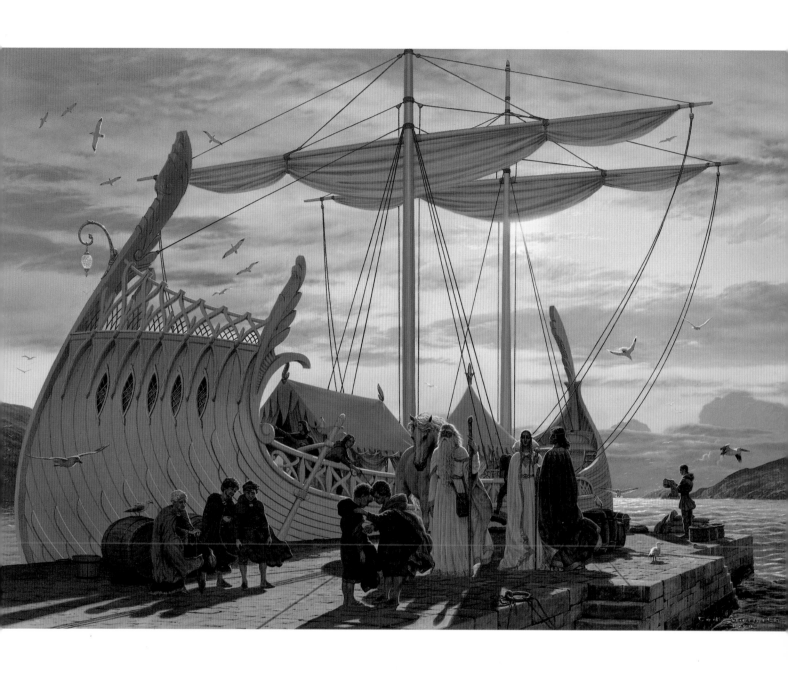

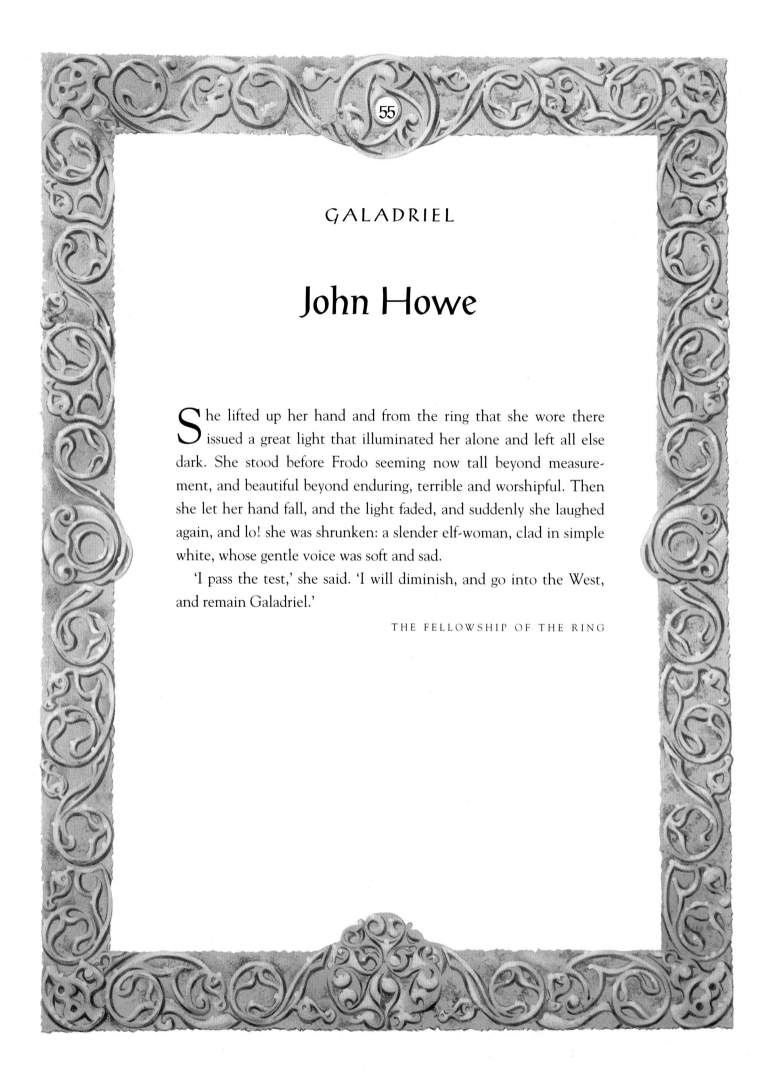

GALADRIEL

John Howe

She lifted up her hand and from the ring that she wore there issued a great light that illuminated her alone and left all else dark. She stood before Frodo seeming now tall beyond measurement, and beautiful beyond enduring, terrible and worshipful. Then she let her hand fall, and the light faded, and suddenly she laughed again, and lo! she was shrunken: a slender elf-woman, clad in simple white, whose gentle voice was soft and sad.

'I pass the test,' she said. 'I will diminish, and go into the West, and remain Galadriel.'

THE FELLOWSHIP OF THE RING

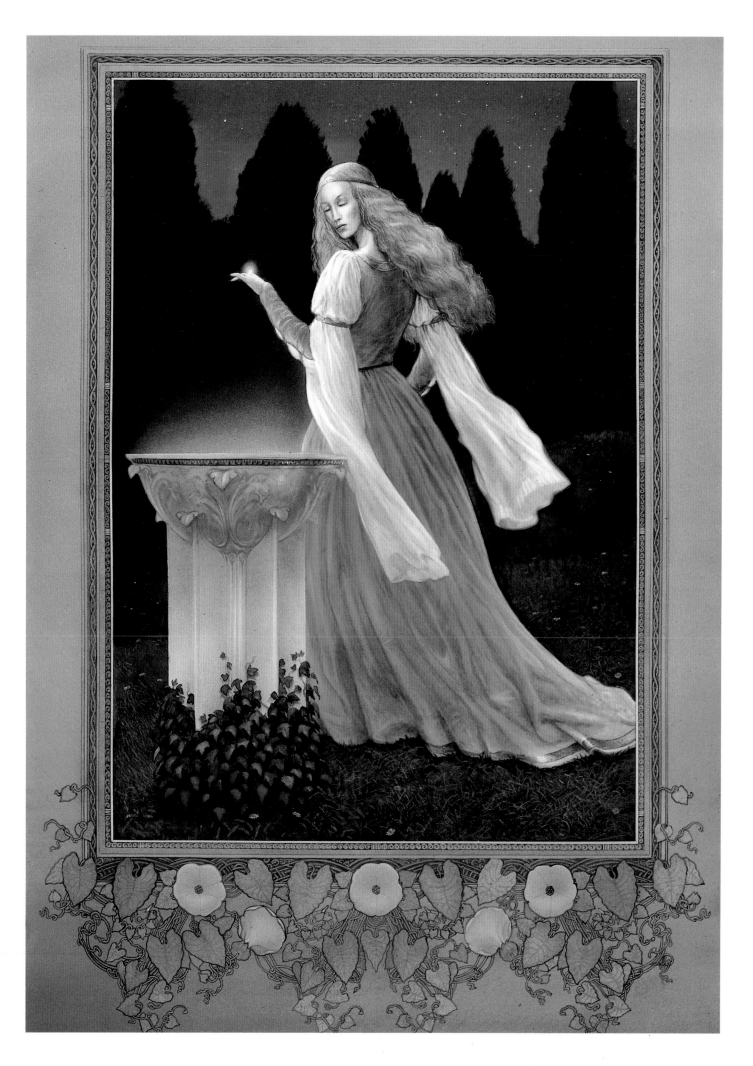

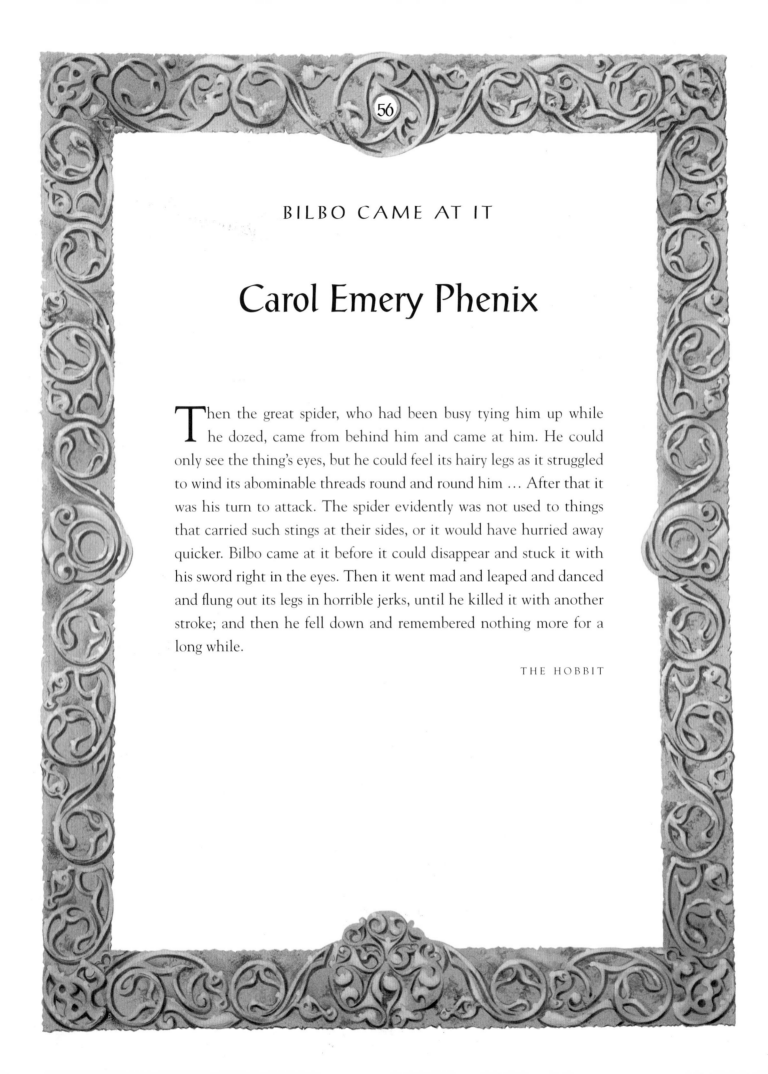

BILBO CAME AT IT

Carol Emery Phenix

Then the great spider, who had been busy tying him up while he dozed, came from behind him and came at him. He could only see the thing's eyes, but he could feel its hairy legs as it struggled to wind its abominable threads round and round him … After that it was his turn to attack. The spider evidently was not used to things that carried such stings at their sides, or it would have hurried away quicker. Bilbo came at it before it could disappear and stuck it with his sword right in the eyes. Then it went mad and leaped and danced and flung out its legs in horrible jerks, until he killed it with another stroke; and then he fell down and remembered nothing more for a long while.

THE HOBBIT

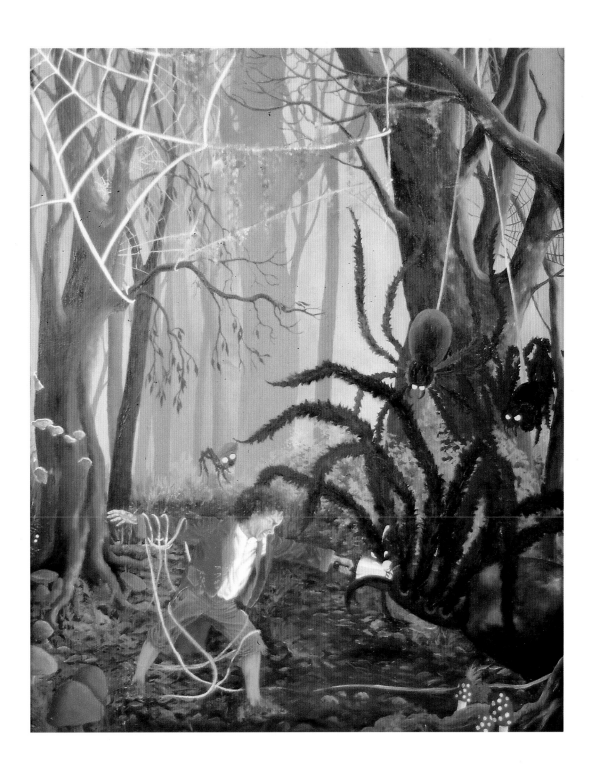

Stephen Hickman

THE BLACK RIDER

'There's been a strange customer asking for Mr. Baggins of Bag End, and he's only just gone. I've sent him on to Bucklebury. Not that I like the sound of him. He seemed mighty put out, when I told him Mr. Baggins had left his old home for good. Hissed at me, he did. It gave me quite a shudder. What sort of fellow was he? says I to the Gaffer. I don't know, says he; but he wasn't a hobbit. He was tall and black-like, and he stooped over me. I reckon it was one of the Big Folk from foreign parts. He spoke funny.'

THE FELLOWSHIP OF THE RING

58

THE SIEGE OF GONDOR

The drums rolled louder. Fires leaped up. Great engines crawled across the field; and in the midst was a huge ram, great as a forest-tree a hundred feet in length, swinging on mighty chains. Long had it been forging in the dark smithies of Mordor, and its hideous head, founded of black steel, was shaped in the likeness of a ravening wolf; on it spells of ruin lay …

Over the hills of slain a hideous shape appeared: a horseman, tall, hooded, cloaked in black. Slowly, trampling the fallen, he rode forth, heeding no longer any dart. He halted and held up a long pale sword. And as he did so a greater fear fell on all, defender and foe alike; and the hands of men drooped to their sides, and no bow sang. For a moment all was still.

THE RETURN OF THE KING

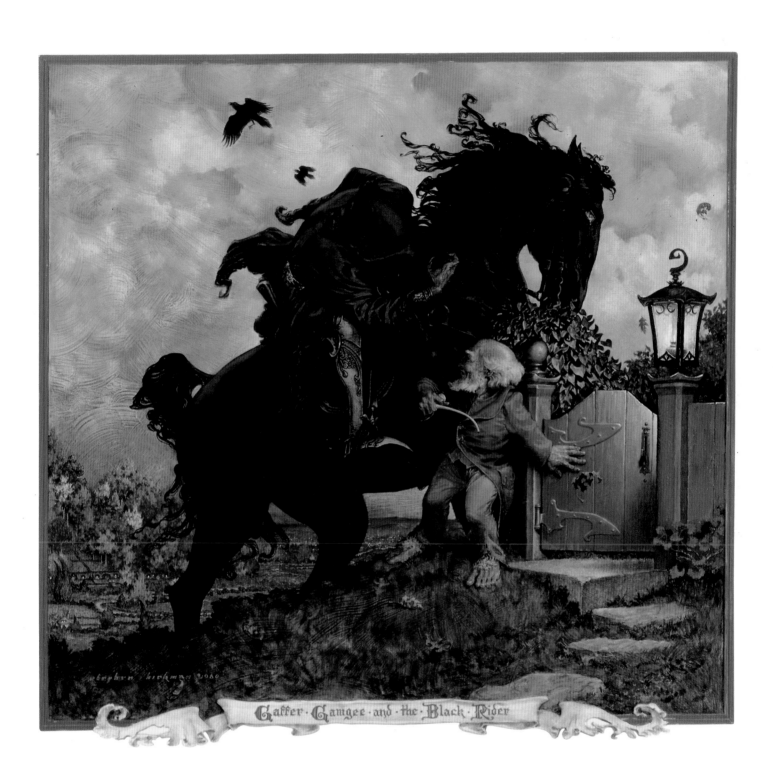

Gaffer Gamgee and the Black Rider

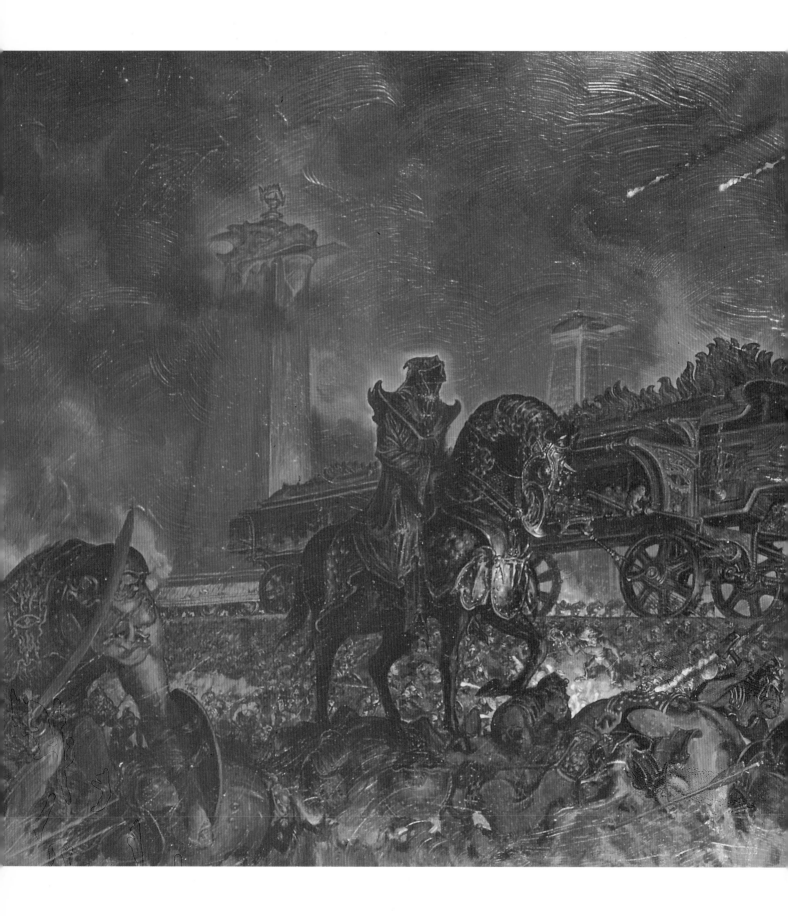

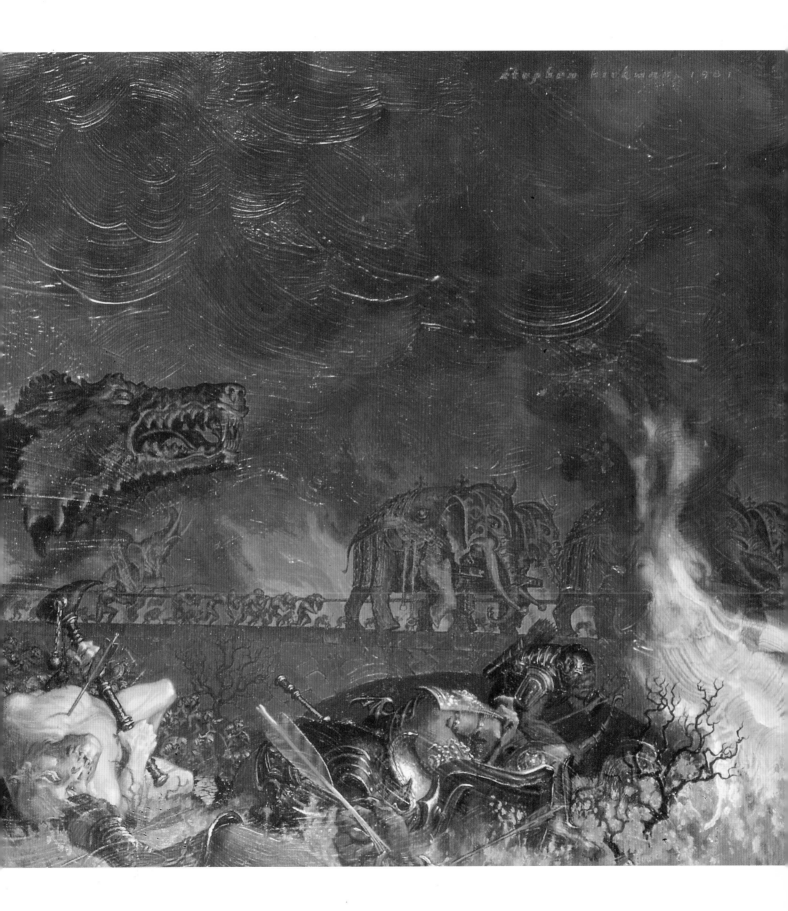

ABOUT THE ARTISTS

Cor Blok

With the Bayeux Tapestry in mind, Cor Blok wanted to tell a story with a series of paintings. His brother suggested *The Lord of the Rings* to him; its sense of adventure particularly appealed to Blok and between 1959 and 1961 he created about a hundred gouaches, illustrating scenes from the book. While preparing an exhibition of Blok's work in the Hague, a gallery owner suggested that he contact JRR Tolkien to find out his opinion of his works. A meeting was arranged and in late 1961 Blok set sail for Oxford with a stack of paintings under his arm.

He met Tolkien at his house in Sandfield Road. The hour-and-a-half conversation in the study was rather one-sided, as Blok was far too impressed to say much. Tolkien talked about art in general and illustrating his work in particular. He showed Blok his own paintings, of which Tolkien himself was very dismissive. In a letter of February 1st, 1962 Tolkien wrote to Cor Blok: 'I am doubtful about my own illustrations, as you are kind enough to call them. I am afraid they have small value even as mere illustrations.' On the other hand, Tolkien liked Blok's illustrations very much. Not only did he admire the technique, he appreciated that Blok left plenty of room for the reader's imagination. Indeed, Tolkien bought two of the paintings ('The Battle of the Hornburg' and 'The Dead Marshes') and Blok gave him a third – 'Dunharrow' – as a gift.

In a postscript to a letter of August 22nd, 1964 to Blok, Tolkien wrote: 'I have had 'Dunharrow' and 'Helm's Deep' framed and they attract the immediate attention of visitors to my home.' With Tolkien's endorsement, the Dutch publisher Het Spectrum decided to put three of Blok's paintings on the covers of their translation of *The Lord of the Rings*. This edition stayed in print for almost twenty years; Blok's work is therefore very familiar to Dutch Tolkien enthusiasts.

In 1992 his work was on show again after 30 years, in the Tolkien Centenary Exhibition 'Hobbits in Holland' held at the Royal Library in the Hague. It was organized by the Dutch Tolkien Society Unquendor, where it attracted much interest.

Lode Claes

The Belgian artist Lode Claes studied under Armand Knaepen at the Municipal Drawing Academy of his hometown of Tienen, near Brussels, Belgium. After graduating he made a living as a house painter, illustrations being just a pastime. Only later in life, especially after his retirement, did he devote himself fully to his art.

He started working in oils, but changed to pencil drawings – first in black and white, but then in colour. His first exhibition, in 1980, opened to great critical acclaim. In the mid-eighties a fellow artist, the potter Sigrid Joosen, suggested that he read *The Lord of the Rings* as a source of inspiration. The result was a series of thirty-three large colour drawings, including several triptychs. He received his first international exposure for this work in 1990 at the Tolkien exhibition, organized by the Dutch Tolkien Society Unquendor, during the World SF Convention 'ConFiction' in the Hague. Even the ever-critical Tolkien aficionados were full of praise.

The success of the exhibition stimulated Claes to continue illustrating Tolkien's works. He then turned his attention to *The Silmarillion*, for which he produced two series of paintings. One tells in twenty paintings the moving story of Beren and Lúthien, while in the other series twenty-three illustrations cover various other stories in *The Silmarillion*. Both the original paintings and the limited art prints have proved to be very popular – with Tolkien fans and art lovers alike.

Inger Edelfeldt

When HarperCollins got in touch with me about one or two illustrations of scenes from *The Lord of the Rings* my first reaction was negative; it was over ten years since I had last painted something that was inspired by Tolkien. Having been a devoted admirer of the books from age fourteen to twenty-eight or so, you could say I had received a Tolkien overdose!

Or so I arrogantly thought. For when I re-read the trilogy, on the lookout for seldom-illustrated scenes, I once again became totally captivated by the tale … and consequently created two new pictures. One of Treebeard and the other one of Gollum held captive by the Elves – an episode referred to by Aragorn in the chapter The Council of Elrond.

I suppose my enthusiasm goes to prove that old loves never really die, but above all that one cannot but surrender to a tale that is of course one of the masterpieces of modern literature.

Carol Emery Phenix

I was born and grew up in Manchester, New Hampshire, USA and for the last ten years have made my home in the White Mountains of New Hampshire.

I was introduced to JRR Tolkien's *The Hobbit* and *The Lord of the Rings* at the age of sixteen. The complexity of Middle-earth; the exactness of detail used in its description; its allusions to times and events and persons of importance outside the main story; the completeness of its cosmology; and especially that intangible 'Northern' atmosphere all served to enthral me completely. I was one of those fans who read the series over and over, each time finding new elements to savour, like a complex painting.

In recent years I have become more attuned particularly to Tolkien's interweaving of his moral thinking into the fabric of his tale. His characters especially seem to be defined chiefly by their moral stature: the consummate evil of Sauron, the blindly horrible Balrog, tempted and wavering Boromir, who falls but overcomes in the end; the mature, developed, clear-thinking Aragorn; and finally the refinement of Frodo into a person of such moral insight as to approach sanctity. Though idealised, I love them all.

The Lord of the Rings still holds incredible power for me, even after a twenty-two year acquaintance. I shall never tire of illustrating Tolkien.

Fletcher

It's always a bit difficult to pin down the scenes you imagine when you read a book into solid pictures on a canvas. Hobbits are a good example of this, because you get a definite feeling for what they're like without really seeing them in your mind's eye. That's why I don't do them.

On the other hand, the great thing about Tolkien is the way he tucks little scenes into the writing that can almost pass you by until you stop and think, 'Hold on, what have I just missed?' That's how I felt about 'Gandalf's Escape from Orthanc', which Tolkien describes almost casually at the Council of Elrond. It's only when you go back to read it again that you realize what a magnificent image it is – an old wizard being whisked from the top of a tower by a giant eagle in the moonlight. It almost begs someone to paint it, so I did.

'The Lord of the Nazgûl' is a little more obvious, but seemed like a challenge that Tolkien is throwing down to illustrators everywhere: 'Here's a character with eyes of fire but no face to put them in, and what's more he's in the smoke and chaos of battle. Now paint him!' I've given it a go but I'm fairly sure you'll have imagined it totally differently and so, no doubt, did Tolkien himself. In fact, when I see other illustrators' pictures I can sometimes think: 'Did they read the same book as me?' But that's the fun of it I suppose.

Unfortunately I can't spend as much time as I'd like taking these wild flights of imaginations – the mortgage dictates a rather more mundane use of my energy. However, after a morning of rent-a-car brochure designs and an afternoon of Inland Revenue forms it's easy to give in to the temptation of strange worlds and terrible wars. I'd probably do it just for fun if nobody else commissioned me, but I wouldn't want HarperCollins to hear me say that.

Tony Galuidi

Mythologies have always drawn me. As a child I was fascinated by such gruesome creatures as the gorgons and hydra of Greek mythology and as I grew older I was moved more by the heroism, dignity, tragedy and beauty that most mythologies contain. Most inspiring to me are the grim, fierce tales of Norse mythology and the sadness and gallantry of Arthurian legend – hence my great love of Tolkien's writings which contain powerful elements of both.

I first read *The Lord of the Rings* about fourteen years ago and no book has moved me so profoundly – so rich is it with dignity and power, so full of hope and heroism. The characters and places within the book are so vibrant and potent that they virtually leap onto the artist's canvas. Shelob is a classic Tolkien monster and stands in the company of trolls and balrogs. As such, I'm sure she exists within the portfolios of many Tolkien painters – I certainly enjoyed adding her to mine. The painting of Balin's Tomb in Moria is probably one of my personal favourites. I was so impressed by Tolkien's description of those mighty, moody underground halls that I was compelled to place that image onto canvas. I hope in this painting I have captured just a little of that awesome grandeur and atmosphere.

I am a self-taught and relative newcomer to painting, having only begun nine years ago, and have very little time to paint due to work and family commitments. I work alongside adults with learning difficulty at a training centre in Skelton, Cleveland, which I find very rewarding. Like most artists I have a deep reservoir of creative impressions and inspirations from which to draw. Tennyson's Arthurian epic *The Idylls of the King* continually rouses me as does the Anglo-Saxon poem *Beowulf*. For me the Victorians are the last word in painting and I admire the work of the Pre-Raphaelite painter, Waterhouse, above all other artists.

Stephen Hickman

Stephen Hickman was born in 1949 in Washington DC into a foreign service family, and travelled with them to various parts of the globe.

He discovered the works of JRR Tolkien while attending art school in Richmond VA, and has been building up his visualizations of the scenes and characters of *The Lord of the Rings* trilogy ever since.

He works as an illustrator of fantasy and science-fiction in the media of painting and sculpture, and has even tried his hand at the craft of writing. His paintings have been exhibited in a number of museums and galleries, including the Delaware Museum of Art, The New Britain Art Museum, The Canton Museum of Art, and the National Air and Space Museum. In 1993 he was commissioned by the United States Postal Service to produce a series of postage stamps honouring the science fiction genre, for which he received the Hugo Award from the World Science Fiction Convention in 1994.

He is currently working with the Greenwich Workshop to develop a series of limited edition prints of Utopian landscapes and mainstream literature themes. His first commercially produced sculpture will be released this year by Bowen Designs, a statuette from the HP Lovecraft story *The Call of Cthulhu*.

John Howe

Illustrating the works of JRR Tolkien means deciding what is best not illustrated, deciding what needs deep shadow or distance or slanting November light. Tolkien is the master of evocation – his descriptions are catalysts for the reader, who summons his own personal pantheon of heroes and demons to complete the picture. Illustrating Tolkien means confronting these nebulous certitudes, radically differing from one reader to the next.

Illustrating Tolkien means treading warily, dipping one's brushes in shadow and rinsing them in light. Battle and dance, down the impossible path between the clear and the obscure.

Somewhat shamefacedly I am obliged to admit that I first read *The Two Towers* and *The Return of the King*, and finally *The Fellowship of the Ring*. I believe I was 12 or so at the time (I had read *The Hobbit* several years before), and the road to higher fantasy was only to be reached through the shelves of a small town public library.

Thus, I plunged directly into the world of Tolkien just above The Falls of Rauros and have been swimming diligently ever since.

John Howe was born in Canada and attended art school in France. He currently lives in Switzerland with his wife Fataneh, who is also an illustrator, and their eight year old son Dana. His work has featured in several previous Tolkien Calendars and on posters commemorating the 50th anniversary of the publication of *The Hobbit* and the Centenary edition of Tolkien's birth. He has illustrated the paperback editions of *The Hobbit* and *The Lord of the Rings* trilogy and also the complete series of *The History of Middle-earth* by Christopher Tolkien.

Timothy Ide

My first introduction to Tolkien's *The Hobbit* and *The Lord of the Rings* was in my first year at High School. It made a big impression on me and the following year when the BBC radio drama series of *The Lord of the Rings* was broadcast I would listen religiously every weekend for the next half-hour instalment. A lot of my visual impressions of Middle-earth came from listening to this series and imagining the characters around the voices.

A lot of my artistic development can be traced back to Tolkien. When I was in ninth year high school, I was greatly inspired by interpretations of Tolkien's work by such artists as Ian Miller, John Blanch and Victor Ambrus; I would spend hours looking at all the detail in each one.

Illustrating Tolkien is an easy task, because of his wonderfully descriptive passages describing each location and atmosphere. His characters also evoke very strong visual images. Creating each picture is also a bit like an entertaining jigsaw, working out what goes where, what the characters are wearing and so on.

I live and work in Adelaide, South Australia as a freelance artist. My interest as an artist has always been in the field of fantasy. Illustrating scenes from Tolkien's Middle-earth is to me one of those things that demands to be done again and again.

Alan Lee

My chief concern in illustrating *The Lord of the Rings* was in attempting to provide a visual accompaniment for the story without interfering with, or dislodging, the pictures the author is carefully building up in the reader's mind. I felt that my task lay in shadowing the heroes on their epic quest, often at a distance, closing in on them at times of heightened emotion but avoiding trying to re-create the dramatic high points of the text.

Such considerations were made simpler by technical ones. Printed separately on a coated art paper, the pictures had to be positioned at intervals of sixteen or thirty-two pages throughout the book. This limitation was received gratefully and probably saved weeks of fruitless agonizing over which moments to illustrate.

It was important that every picture should be relevant to the text on the opposite page. It also suited my inclination towards finding subjects in some of the less obvious places.

It is such a rich work though that there are few, if any, pages in which something dramatic, wonderful or terrifying is not happening somewhere – and passages so beautiful and elegiac that any attempts to make them visible seem clumsy by comparison.

Tolkien succeeded in creating a world which exists beyond the scope of his own narrative. By establishing such a powerfully imagined landscape, and firm foundations of history and myth, he has made Middle-earth available to all of us for our own imaginative wanderings.

I feel immensely privileged to have been allowed to illustrate *The Lord of the Rings*, a book which has a profound impact on first reading and which has probably influenced the direction of my career over the following twenty-five years. It steered me, not towards fantasy, but to an invigorated interest in myth and legend, and a lifelong appreciation of the wonderful skills of the storyteller.

Alan Lee has also illustrated David Day's *Tolkien's Ring* and is currently at work on the illustration of *The Hobbit*.

Capucine Mazille

The Dutch artist Capucine Mazille was born in the Hague, Holland, in 1953 where she studied at the prestigious Royal Academy. For almost twenty years now she has been living in France. She has built up an international reputation as an illustrator of children's books and she exhibits her work regularly all over Europe, especially in Switzerland, France and The Netherlands. She has illustrated books for publishers like Fleurus, Eisele and Bayard Presse.

As an illustrator of children's books her favourite novel by JRR Tolkien is *The Hobbit*. For her own pleasure she painted eight watercolours illustrating scenes from that novel, including the delicate 'Bilbo in front of his smial at Bag-End' and the impressive 'The Battle of the Five Armies'. She is also one of the very few artists who made an illustration for Tolkien's lovely allegory *Leaf by Niggle*. It is odd that most illustrators overlook this story, especially since the main character is a painter.

Her Tolkien paintings were selected for the illustrators' exhibition of the International Children's Book Fair at Bologna, Italy in 1987. They were also included in the 1992 Tolkien exhibition in Antwerp, Belgium.

Ted Nasmith

Ted Nasmith lives and works in Markham, Canada. As an illustrator he divides his time between architectural rendering and a variety of other forms of illustration, particularly the Tolkien paintings he is becoming renowned for. Among several other interests are a love of songwriting, singing and recording, and of books: 'There are an overwhelming number of good ones.'

His love of Tolkien inspired him to create illustrations from the first reading of *The Lord of the Rings* at age fifteen. He was soon embarking on ambitious, detailed interpretations of scene after scene from the book, while accumulating a body of sketches. The first major piece was entitled 'The Unexpected Party' (1972), rendered in tempera. It featured Gandalf, Bilbo and the dwarves examining the ancient map of Erebor. Photographs of this and one or two other early works were shown to JRR Tolkien himself and earned a favourable response. With encouragement, he continued to turn out Tolkien illustrations in his own time for over a decade, some of which were to take many months to finish. In time his work was brought to the attention of George Allen & Unwin Ltd. and was soon being published in the Tolkien Calendars (1987, 1988, 1990, 1992 and 1996).

Says Nasmith: 'When I interpret Tolkien, I feel genuinely at home with it and I derive great satisfaction from exploring all potential aspects of Middle-earth. With each new illustration I feel a little bit more of it is captured: characters, locales, atmosphere and drama. Also, it is always interesting to discover the ways that a picture can add new layers of meaning to a scene when the various elements of the composition come together, and how unconscious associations find their way into the work. There doesn't seem to be any limit to the possibilities and as far as I can tell, I will be exploring them for some time to come.'

Michael Kaluta

Michael William Kaluta was born on August 15, 1947 in Guatemala City, the son of American parents. His early art influences included his high school art teachers at the Washington-Lee High School in Arlington, Virginia. He also studied art at the Richmond Professional Institute, now Virginia Commonwealth University.

Since then he has worked for DC Comics, *Fantastic Stories* and *Amazing Stories*, *National Lampoon* and a variety of film studios. His illustrative work includes several *Batman* covers, *The Shadow*, *Starstruck*, *Bill the Galactic Hero* and *The Abyss*. He also illustrated the 1992 Tolkien Calendar, fulfilling a long-cherished ambition.

Nicholas Bayrachny

Nicholas Bayrachny was born in 1950 and is one of the outstanding Bellorussian sculptors and artists. He has illustrated about one hundred different books, including a decorative version of *The Hobbit*, from which his three illustrations are taken.

Gerd Renshoff and Ron Ploeg

Gerd Renshoff and Ron Ploeg met at art school in 1980 and have been friends (and colleagues) ever since. As they both were fond of the works of JRR Tolkien they started making illustrations for the stories on a non-commercial basis. In 1983 they bought an old van and toured England in search of the places that would have inspired Tolkien according to Humphrey Carpenter's biography.

In 1985 Ron did a teacher's training course in Oxford, and since then enjoys a pint at 'The Eagle and Child' (known affectionately to Tolkien and his friends as 'The Bird and Baby') on a very frequent basis. In the meantime he joined the Dutch Tolkien Society Unquendor, and was for years the 'innkeeper' of Nijmegen's 'smial Ar Caras' – the local gathering-point for Tolkien enthusiasts. Gerd and Ron made a series of colour illustrations based on *Farmer Giles of Ham* (Ron does the drawing whilst Gerd does the colouring), and also some based on *The Hobbit* and *The Lord of the Rings*.

Gerd lives in Arnhem and works as an artist (mainly oil paintings) – he exhibits regularly. Ron lives nearby in Nijmegen and is a freelance illustrator.

The Italian Tolkien Society

The Italian Tolkien Society was founded in February 1994 with the principal purpose of spreading and deepening the study of JRR Tolkien's work and thought. Several events and activities have developed since 1994 in order to pursue this aim: once a year they hold a great national feast called 'Hobbiton' which includes lectures, meetings, talks, dances and theatrical performances, games and costumes related to the world of Middle-earth.

Two journals are printed: 'Terra di Mezzo' with issues in March and September and 'Minas Tirith' with issues in September and June. They both offer articles, surveys and studies on Professor Tolkien, his work and the great traditional sources from which it draws.

The Silmaril Prize is announced yearly for paintings and writings; the best pictures are published in a calendar the following year.

Pictures have been selected for reproduction in *Realms of Tolkien* by the following artists:

ALESSANDRA CIMATORIBUS has illustrated several publications and lives in Pordenone.

MAURA BOLDI works with publishers, has already been awarded prizes in the past and lives in Brescia.

LUCA MICHELUCCI is an amateur, self-taught and lives in Milan.

ETA MUSCAD is an established Italian fantasy artist who has illustrated covers for many publishers, both national and international. She lives in Aosta.